scandinavian needlecraft

35 step-by-step projects to create the scandinavian home

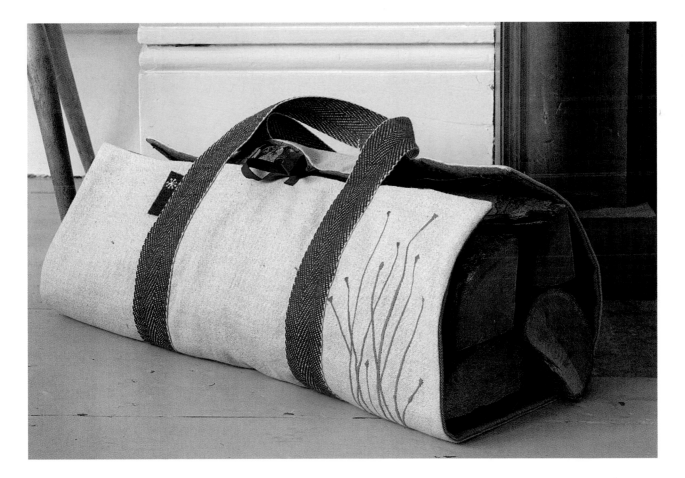

CLARE YOUNGS

CICO BOOKS

LONDON NEW YORK

Published in 2010 by CICO Books
An imprint of Ryland Peters & Small Ltd
20–21 Jockey's Fields 519 Broadway, 5th Floor
London WC1R 4BW New York, NY 10012

www.cicobooks.com

10 9 8 7 6 5 4 3 2

A CIP catalog record for this book is available from
the Library of Congress and the British Library.

ISBN-13: 978 1 907030 22 2

Printed in China

Editor: Sarah Hoggett
Design: Christine Wood
Photography: Claire Richardson. Additional photography on pages 26,
27, 29, 31, 48, 49, 52, 53, 76, 77, 92, and 93 by Carolyn Barber
Illustration: Kate Simunek

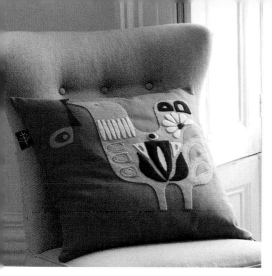

contents

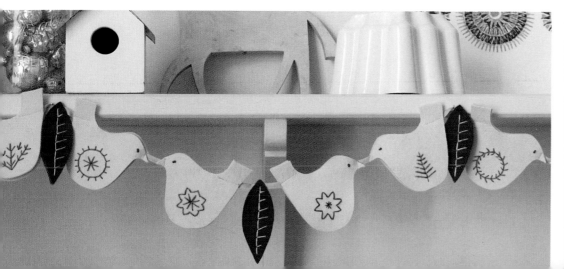

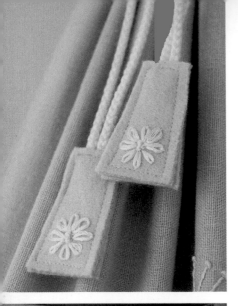

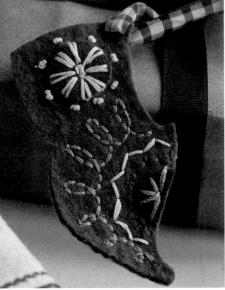

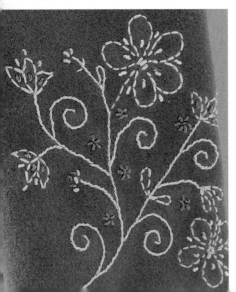

introduction

Scandinavia is made up of five countries—Denmark, Finland, Iceland, Norway, and Sweden—with a varied landscape of forests, lakes, mountains, rivers, and thousands of islands forming archipelagos along rocky coastlines. For three months of the year, the days are long, and filled with light; for the rest of the year, the days are short and the nights long and cold. The home is the center of family life and there is an eagerness to fill it with warmth and light and make it a cozy place to see out the winter months.

The area has a long tradition of folk art and craftsmanship. The practicalities of remote, rural life and limited resources have led to an understanding of the simple, honest beauty of natural raw materials such as linen, wool, and wood. The countries are steeped in myths, legends, and traditions that have been cherished and handed down through generations, and many of these have found their way into traditional motifs on furniture, ornaments, and clothing. At the same time, handicraft goes hand in hand with a respect for the natural world: animals, natural forms, plants, flowers and trees, and the changing seasons have all been sources of inspiration in Scandinavian design. The pale colors used in Scandinavian interiors reflect the clear northern light. The color palette is made up of tones of chalky whites, silver grays, milky blues, and soft greens. Cheery, vibrant reds, blues, greens, and yellows are picked out on furniture and in the soft furnishings, to make the home a comfortable and welcoming place. It is all about *hygge*—a Danish word that means a sense of wellbeing, a comfortable feeling, coziness, and pleasure in the simple things in life.

It is a look that I—and many other people—love. The unpretentious balance between function and beauty, the calm serenity of pale, uncluttered interiors, and the use of beautiful natural materials have made Scandinavian design renowned the world over. This collection is largely inspired by my love of Scandinavian textiles, from early traditional embroidery to the bold, abstract, and innovative fabrics of the Finnish textile company Marimekko in the

1960s and '70s, to the wonderfully colorful and organic designs of Josef Frank, with so much in between. But I have also looked at many other aspects of Scandinavian design in my research, from beautifully painted folk-art furniture and murals and the intricate, hand-carved wooden furniture of the 18th century to traditional ceramics of the 19th century, as well as more recent designers such as the Swedish modernist Stig Lindberg and the clean lines of Danish designer Arne Jacobsen. I have been inspired by the architecture of Stockholm's Old Town square and by the natural beauty of the Scandinavian landscape, from the pine and birch forests that cover much of northern Scandinavia to the blue, green, and gray colors of the lakes, glaciers, and surrounding seas. In this book, I have tried to translate all these sources, and more, into the medium of textiles without losing any of the spirit and vitality of the original.

Anyone new to sewing will soon realize how relaxing sewing, especially embroidery can be. It is a pleasure to see something develop slowly and the satisfaction you will gain from holding a finished piece sewn by yourself is immense and something to be proud of. You may not get a perfect stitch every time: perfection comes with years of practice, patience, and a willingness to unpick and re-do! But I do not believe embroidery has to be absolutely perfect: the odd wobbly line or a few misplaced stitches all reinforce the charm of a homemade piece.

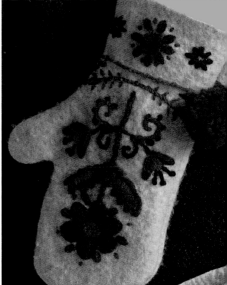

I've given full step-by-step instructions and stitch guides for each project and, if you're new to embroidery or come across a stitch that you're not sure how to work, the techniques section on pages 117–124 will provide all the information you need.

I hope you gain as much pleasure from these projects as I have and they give you the confidence to experiment and develop your own ideas. Before long, you will be making beautiful things for yourself and wonderful gifts for your family and friends.

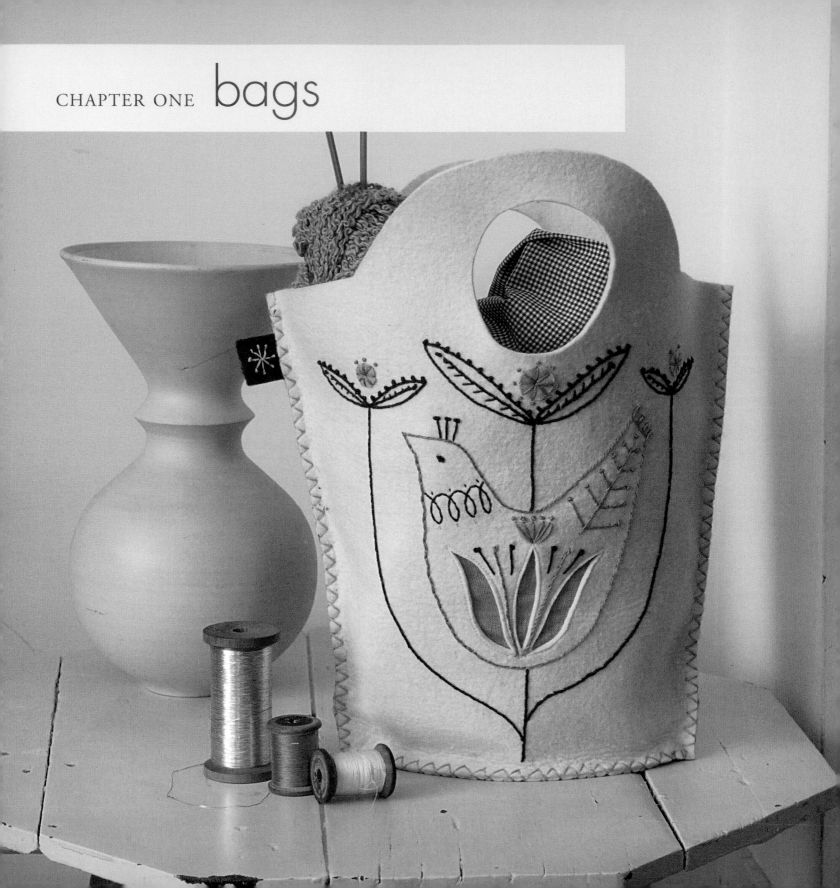

felt bag with embroidered bird

The bird image is a popular motif in Scandinavian craft. Designs are passed on from generation to generation and even today many modern Scandinavian designers reveal their roots in the folk art of years gone by. I made this bag out of beautifully thick felt, which is quite hard to source. Wool felt is the best. If you cannot find any the right thickness, use a double layer of thin felt and machine stitch around the top and handle holes to join the layers together.

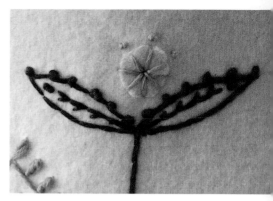

1 Enlarge the bag templates on page 96 by 250 percent (see page 117). Transfer the bag shapes to thick cream felt and the appliqué shapes to thin blue felt, and cut out. Using dressmaker's carbon paper, transfer the stitch design to the front panel of the bag (see page 118). Cut out the three leaf sections from the front panel.

materials

Templates and stitch guide on page 96

40 x 18 in. (100 x 45 cm) thick cream felt

Small piece of blue cotton fabric to go behind the cut-outs

Small piece of blue felt for the appliqué

3½ x 1½ in. (9 x 4 cm) orange felt for the label

Dressmaker's carbon paper

Blue and green stranded embroidery floss (cotton)

2 Place the blue cotton fabric behind the cut-out leaf sections. Pin it in place, making sure that it is free of wrinkles. Using thread that matches the felt, machine topstitch around each cut-out leaf shape, stitching close to the edge.

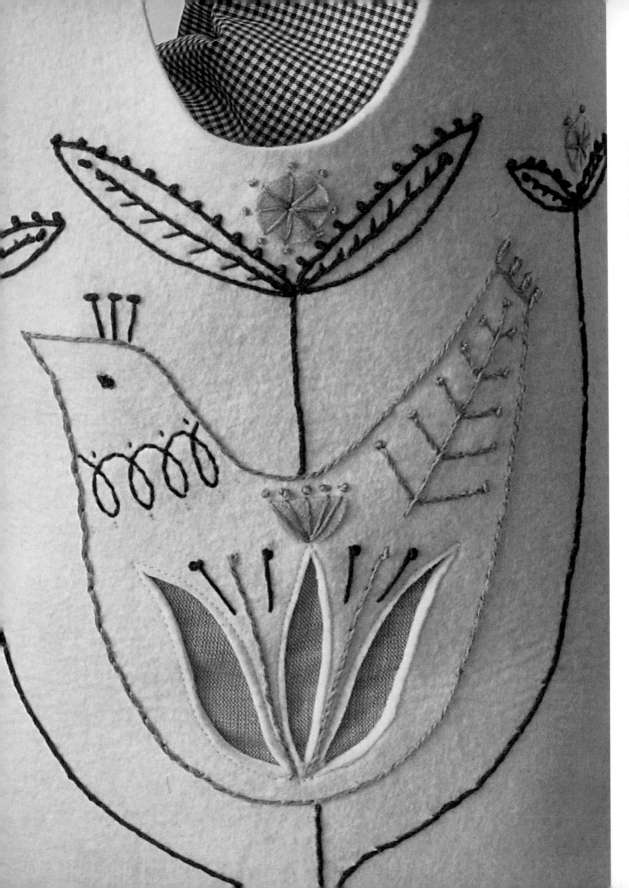

3 Pin, then slipstitch the four blue felt appliqué pieces in position. Following the stitch guide on page 96, embroider the design in blue and green embroidery floss (cotton).

4 Choose one of the motifs from the folk bird garland on page 103 and scale it down to fit on the label (see page 118). Embroider the motif on the right-hand side of the orange felt, leaving ½ in. (1 cm) of felt to tuck into the side seam.

5 Fold the label in half lengthwise and sew up each long side close to the edge.

6 With wrong sides together, pin the front and back panel of the bag together along the side edges, inserting the label in the seam ¾ in. (2 cm) down from the top left edge.

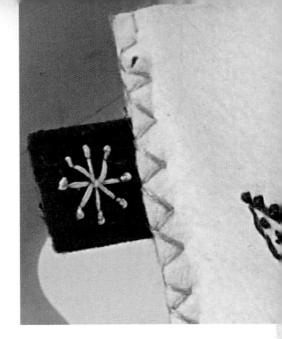

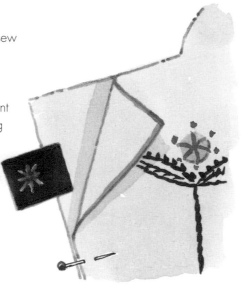

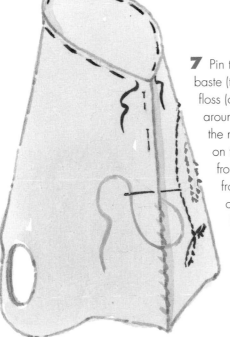

7 Pin the base to the bottom of the bag and baste (tack) it in place. Using blue embroidery floss (cotton), work the decorative cross stitch around the sides and base of the bag. Bring the needle out at the top of one side seam on the right side, about ⅛ in. (3 mm) down from the top of the bag and ¼ in. (5 mm) in from the side. Take the needle over the top of the bag and back through the same hole. Make evenly spaced diagonal stitches all down the side seam and around the base. Fasten off, then work the second side seam in the same way.

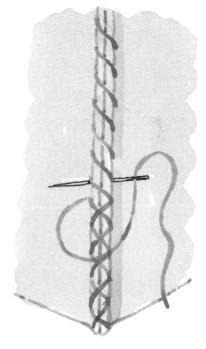

8 Come back the other way, making diagonal stitches that slant in the opposite direction so that they cross over on the joined edge.

blue dandelion felted bag

Much of Scandinavian pattern work is stylized. In the 1950s, a much freer, looser stitch was sometimes used, often adapted from traditional embroidered motifs. I took this style as my inspiration and embroidered a simple dandelion motif on a subtle milky-blue felted wool. Suede handles give the bag that extra-luxurious feel.

materials

Templates and stitch guide on page 97

12½ x 25 in. (32 x 64 cm) blue felted wool

12½ x 25 in. (32 x 64 cm) cotton fabric for lining

Dressmaker's carbon paper or tissue paper

Two 19 x 1½-in. (48 x 4-cm) strips of dark blue or black suede for handles

3 x 1½ in. (8 x 4 cm) orange felt for label

Dark blue and white stranded embroidery floss (cotton)

1 Cut two trapezoid shapes, one front and one back, from both the felted wool and lining fabrics measuring 13 in. (32 cm) high, 10 in. (25 cm) along the base, and 13 in. (32 cm) along the top edge.

2 Enlarge the design on page 97 by 200 percent (see page 117). Using dressmaker's carbon paper or the tissue paper and basting (tacking) method (see page 118), transfer the design to the front of the bag. Following the stitch guide on page 97, using dark blue embroidery floss (cotton), embroider the dandelion.

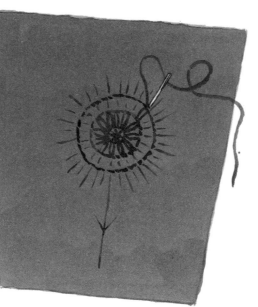

3 Using white stranded embroidery floss (cotton), embroider the label motif on one half of the piece of orange felt. Fold the felt in half widthwise, wrong sides together, and machine stitch down each of the side edges close to the edge.

4 Pin the font and back lining pieces right sides together. Machine stitch down each side and along the bottom of the lining. Trim the seam allowance and cut across the corners to reduce the bulk. Repeat with the front and back bag pieces, positioning the label between the front and back pieces about 1½ in. (4 cm) down from the top and facing in toward the bag.

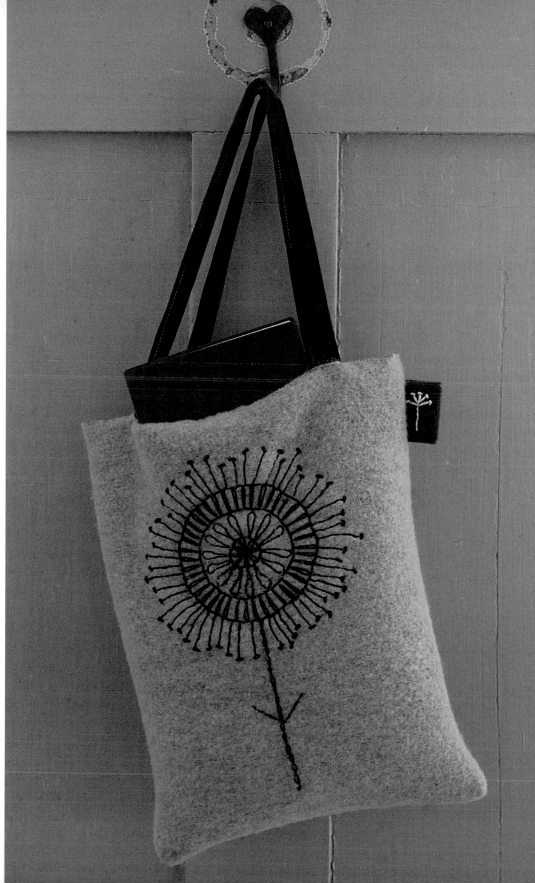

5 To make the handles, fold each piece of suede in half widthwise, wrong sides together. Machine stitch along the long edge, as close to the edge as possible. Position the handle ends inside the bag, about 2½ in. (6 cm) in from each side edge and ½ in. (1 cm) down from the top edge. Pin in place, and machine stitch back and forth across each handle end to secure.

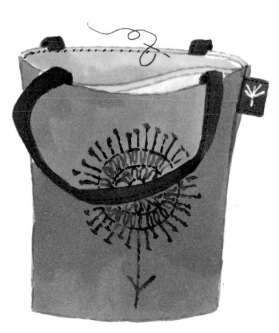

6 With wrong sides together, place the lining inside the bag. Fold over a small double hem at the top edge of the lining and slipstitch the lining in position all around the top edge of the bag (see page 120).

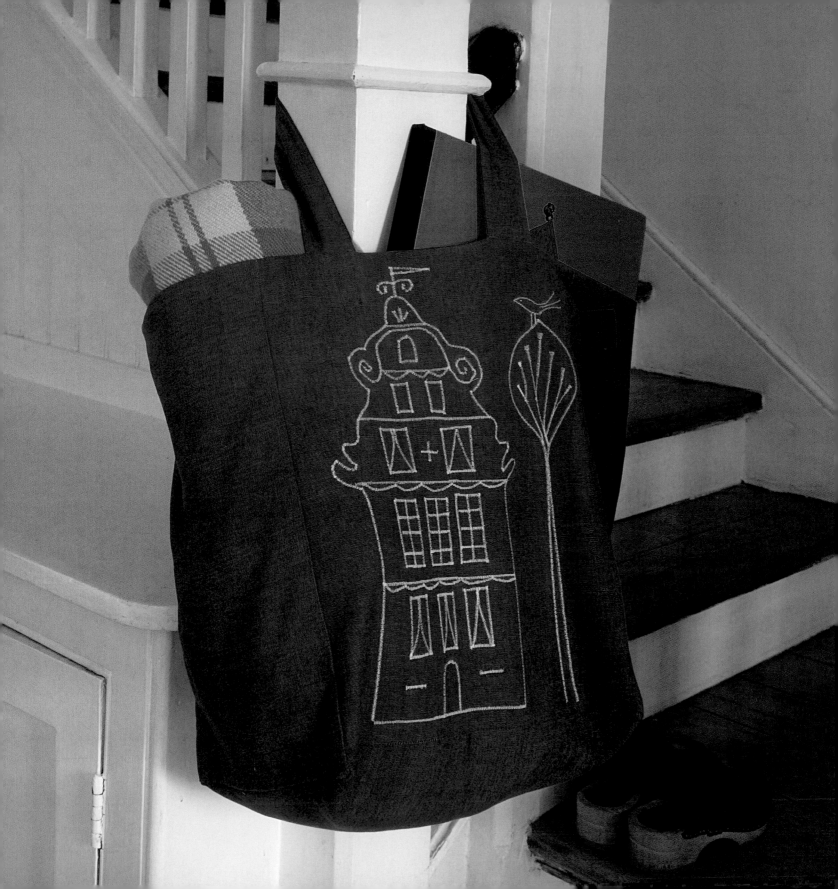

stortorget tote bag

The Stortorget is the main square in the Old Town, the Gamla Stan, of central Stockholm. The square is lined with tall, flat-fronted 17th- and 18th-century houses in shades of ochers and reds, some topped with beautiful curvy façades, which provided the inspiration for this sturdy, roomy bag. Keep it at the bottom of the stairs to store all the clutter that gathers there, or use it as a stylish toy bag, or even a paper recycling bag. You will wonder how you ever managed without it!

materials

Motif on page 97

Dressmaker's carbon paper

Approx. 1¼ yd (1.1 m) blue cotton drill or canvas, 44 in. (112 cm) wide, for the outer bag

Approx. 1¼ yd (1.1 m) red cotton drill, 44 in. (112 cm) wide, for the lining

White sewing cotton

Two 1½ x 2-in. (4 x 5-cm) pieces of green felt for the label

Red stranded embroidery floss (cotton)

1 From both the main fabric and the lining fabric, cut two 13½ x 15¾-in. (34 x 40-cm) pieces for the front and back panels, two 9½ x 15¾-in. (24 x 40-cm) pieces for the side panels, one 9½ x 13½-in. (24 x 34-cm) piece for the base, and two 10½ x 22¾-in. (27 x 58-cm) strips for the handles.

2 Enlarge the motif on page 97 by 200 percent (see page 117). Using dressmaker's carbon paper (see page 118), transfer it to one of the larger side panels in the main blue fabric. Set your sewing machine to a tight narrow zigzag stitch and embroider the design. Adjust the width of the zigzag to make thicker and thinner lines for the twigs in the tree.

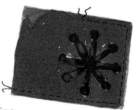

3 Embroider the motif on one of the felt oblongs for the label. Place the two oblongs wrong sides together and machine stitch along the two side edges and the outer edge of the label, stitching as close to the edge as possible.

4 With right sides together, pin the bottom edge of the embroidered front panel to one long side of the base oblong. Starting and finishing ½ in. (1 cm) from the end, taking a ½-in. (1-cm) seam, machine stitch along the length. Attach the side and back panels to the base in the same way. Pin the side seams together, inserting the label in position in the front right seam. 1½ in. (4 cm) from the top and facing inward. Machine stitch. Trim the seam allowance and press the seams open.

5 Repeat Step 3 to make the lining, but leave a 5-in. (12-cm) gap in one side seam.

6 To make the handles, take the two long strips—one of the outer fabric and one of the lining. Pin them right sides together. Taking a ½-in. (1-cm) seam, machine stitch down each long side. Trim the seam allowances to ¼ in. (5mm). Turn right side out. Press. Repeat to make the second handle.

7 With right sides together, place the lining section inside the outer section. Position the handles facing down into the bag, sandwiched between the lining and the outer bag, 2¾ in. (7 cm) in from each side edge on the back and front sections of the bag. Pin in place. Taking a ½-in. (1-cm) seam, machine stitch all around the top edge of the bag.

8 Turn the bag right side out. Slipstitch the gap in the lining seam closed (see page 120). Press.

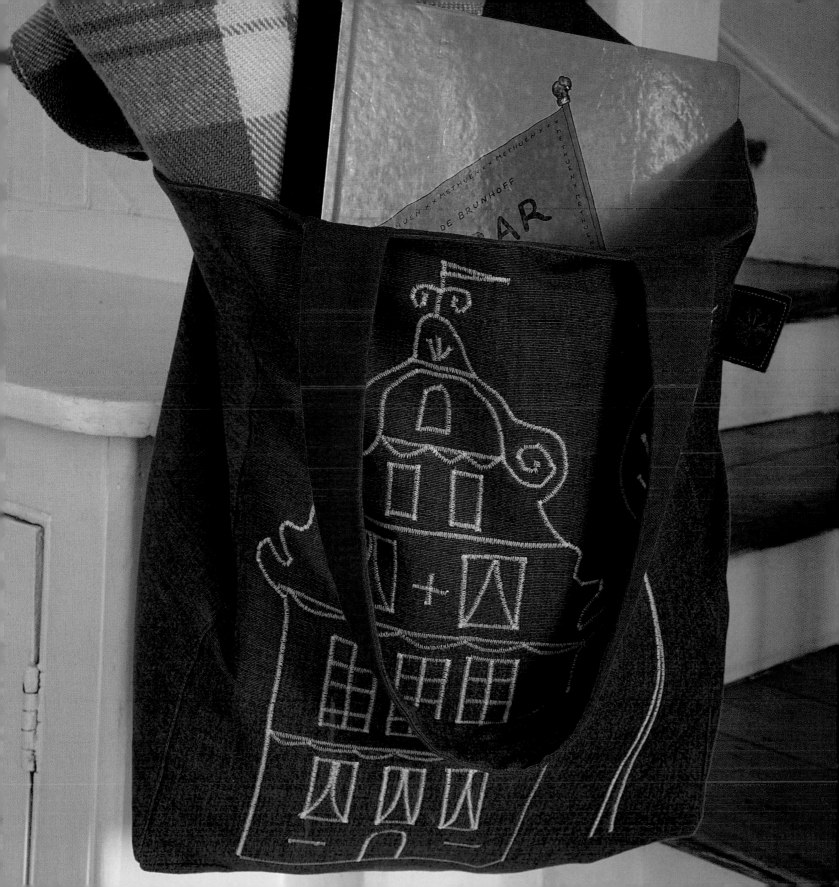

log roll with twig detailing

A stack of logs next to an open fireplace is a homely, comforting sight. Log baskets are a popular way of storing them neatly, but this log roll makes a stylish alternative. Made from thick drill or canvas and finished with a removable liner made of plastic sheeting (bought from a garden center) and strong webbing handles, it is both practical and attractive. The twig design on the front is machine stitched and is inspired by the birch trees of the Scandinavian forests.

materials

Template and stitch guide on page 98

Dressmaker's carbon paper

32 x 24 in. (80 x 60 cm) canvas or drill

32 x 24 in. (80 x 60 cm) denim

32 x 24 in. (80 x 60 cm) plastic sheeting

1¼ x 2¼ in. (3 x 6 cm) orange felt for label

20 in. (50 cm) length of ½-in. (1-cm) black cotton tape

2½-in. (6-cm) length of ½-in. (1-cm) black cotton tape

Two 50-in. (130-cm) strips of 2-in. (5-cm) webbing

4 small pieces of hook-and-loop tape

Blue-gray sewing thread

White stranded embroidery floss (cotton)

1 Enlarge the twig design on page 98 by 200 percent (see page 117). Using dressmaker's carbon paper (see page 118), transfer it to the top right-hand section of the canvas, 1 ½ in. (4 cm) in from the top and side edges.

2 Set your sewing machine to a wide, close zigzag stitch. Stitch the design in blue-gray thread, adjusting the width of the stitch as necessary as you go. If you prefer, you can stitch by hand using satin stitch.

3 Pin the canvas and denim panels right sides together, sandwiching the 20-in. (50-cm) length of black cotton tape between the layers at the center of the bottom seam, making sure that the length is tucked inside.

4 Machine stitch around all sides ½ in. (1 cm) from the edge, leaving a 5-in. (12-cm) gap in one side. Trim across each corner and trim the seam allowance to about ¼ in. (5 mm). Turn the log roll right side out, easing the corners into shape. Turn in the edges of the gap, press, and slipstitch closed.

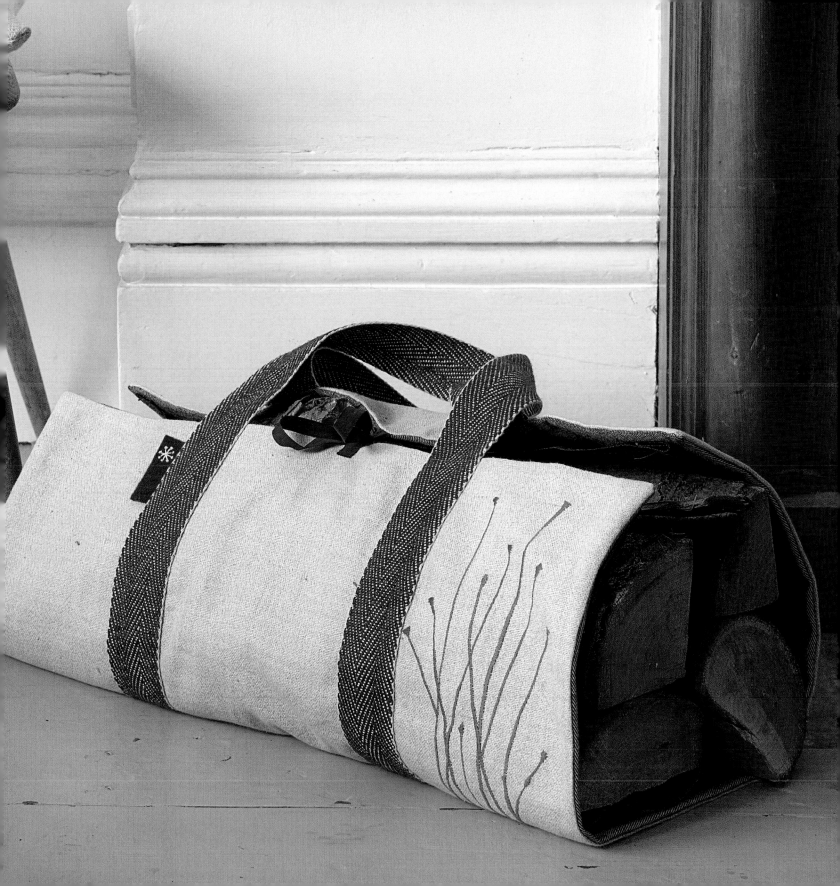

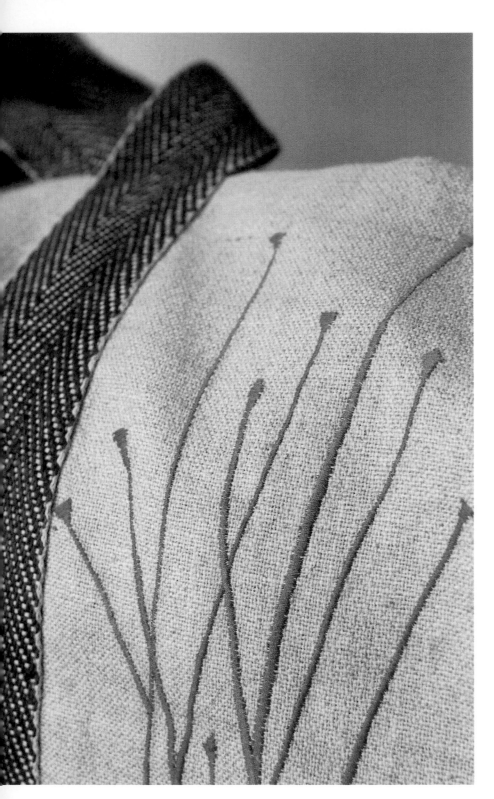

5 Choose one of the motifs from the folk bird garland on page 103 and scale it down to fit on the label (see page 118). Embroider the motif near the top of one short side of the orange felt, using white embroidery floss (cotton).

6 Fold the log roll in half. Starting at the fold, pin one length of webbing to the bag 6 in. (15 cm) in from the right-hand edge. Form the webbing into a loop for the handle, then pin the webbing back down the left-hand side, again positioning it 6 in. (15 cm) in from the edge. Tuck the orange felt label under the webbing, ¾ in. (2 cm) down from the top. Make sure that the webbing starts and ends on the fold. Repeat for the back half of the log roll.

7 Stitch close to the edge all along both sides of the webbing and across the width of the webbing at the edges of the roll. Stitch a row of close zigzag stitches over the raw edges of the webbing, along the folded edge.

8 Fold the 1½-in. (4-cm) piece of black cotton tape for the loop in half lengthwise. Pin the raw edges of the tape to the center top of the log roll, about ½ in. (1 cm) down from the edge. Machine stitch a line of close zigzag stitches over the raw edges.

9 Turn over a double ½-in. (1-cm) hem all around the plastic sheeting and machine stitch. Attach a piece of hook-and-loop tape to each corner on the wrong side of the plastic, and to each corner of the denim lining. Attach the plastic lining to the denim.

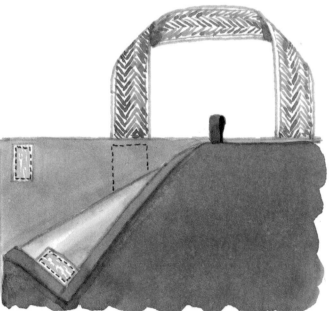

floral cutwork bag

Delicate floral embroidery and cutwork transform this simple drawstring bag into something very special. I have chosen a linen in a duck-egg blue—a favorite color of mine and one that is used throughout Scandinavia in textiles and paintwork. Hang it up in the bathroom to use as a pretty and elegant laundry bag.

materials

Template and stitch guide on page 98

Dressmaker's carbon paper

Two 29 x 20½-in. (74 x 52-cm) pieces of linen

White stranded embroidery floss (cotton)

Air-erasable marker pen

80 in. (2 m) thin cord

Approx. 7-in. (16-cm) square of felt for tags

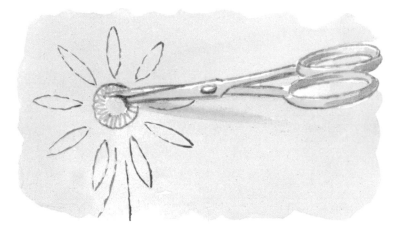

1 Enlarge the motif on page 98 by 242 percent (see page 117). Using dressmaker's carbon paper, transfer the design to the center of one of the pieces of linen (see page 118). Using white stranded embroidery floss (cotton), embroider the areas for the cut-outs in buttonhole stitch (see page 124). Using small, sharp embroidery scissors, cut out the center of the circles, being careful not to cut into any of the stitches.

2 Following the stitch guide on page 98, embroider the rest of the design.

3 Pin the front and back of the bag right sides together. Starting and finishing 5 in. (12.5 cm) from the top edge of each side, taking a ½-in. (1-cm) seam, machine stitch along the bottom edge and the sides.

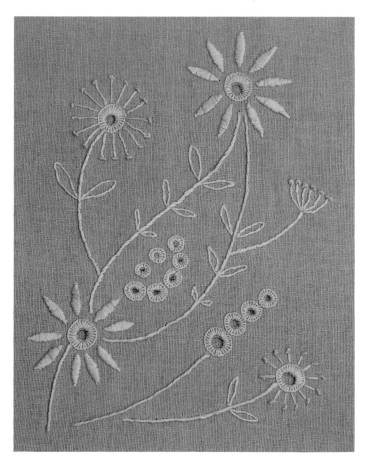

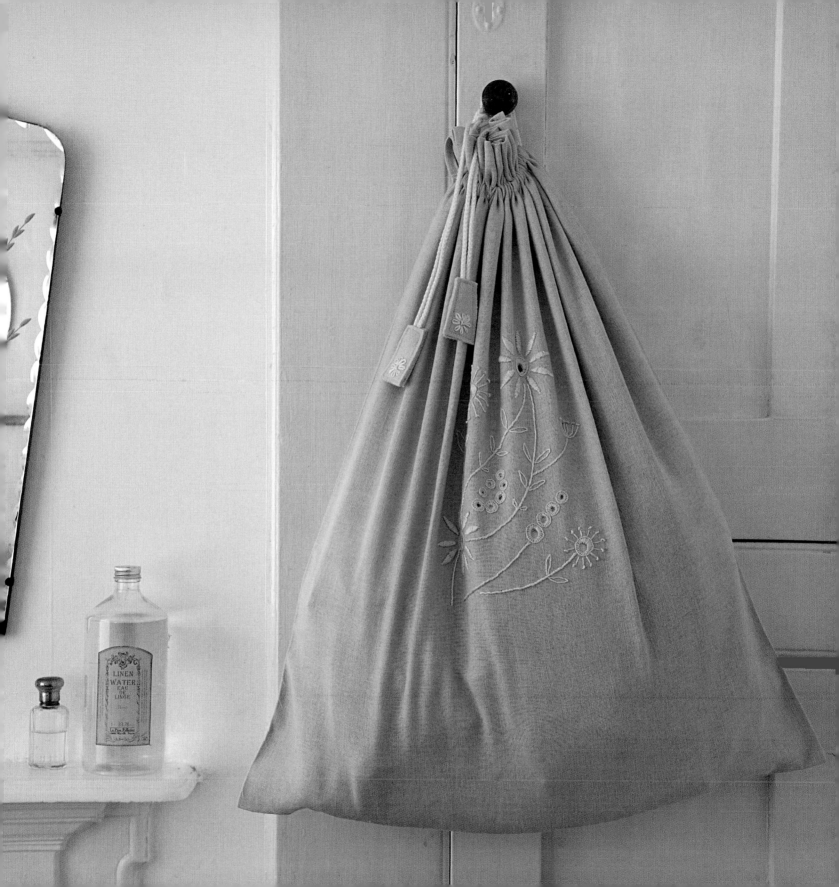

6 Using an air-erasable marker pen, mark a line ¾ in. (2 cm) above this hem. Machine stitch along the line on both the back and the front of the bag to form a channel.

4 Make a ½-in. (1-cm) snip on each raw side edge, just above the seam. On each raw side edge, turn in a ¼-in. (5-mm) double hem on each side edge on both the front and the back panels. Pin and machine stitch, continuing the stitching ½ in. (1 cm) into the seam that joins the back and front panels together.

7 Attach a safety pin to one end of the cord. Thread the cord through the channel on one side of the bag, then come back on the other side. Go around once more on both sides, so that you have a double row of cord on each side.

5 Along the top edge of both the front and the back panels, turn under a ½-in. (1-cm) hem to the wrong side, then turn over a further 2 in. (5 cm) to create the casing for the drawstring. Press and pin in position. Machine stitch close to the edge.

8 Take hold of one piece of cord on each side of the bag and pull to draw the top of the bag together, making sure the same amount of cord protrudes on each side.

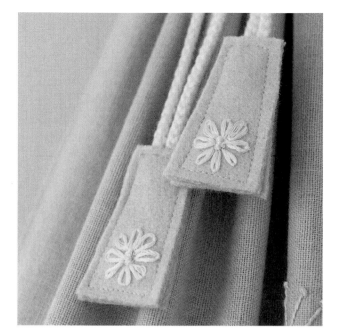

9 Enlarge the tag template on page 98 by 242 percent, and cut out four felt tags. Embroider a daisy on two of the tag pieces. With wrong sides together, pin one front and one back tag together over the ends of the cord on each side of the bag. Machine stitch all around the tags, as close to the edge as possible, to attach them to the cord, making sure you catch the cord in the stitching.

10 Trim the seam allowance and snip across the corners. Turn the bag right side out and press.

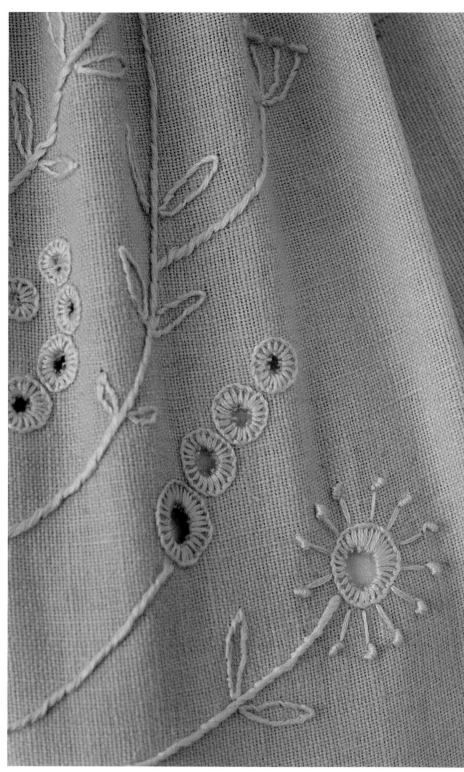

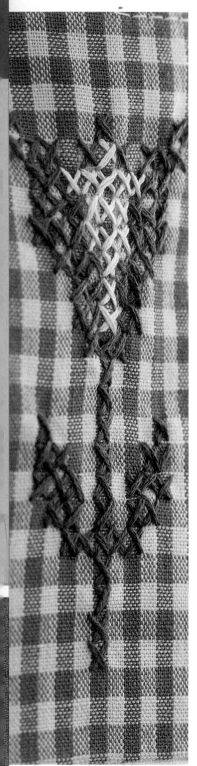

coat hanger cover

This pretty cover transforms a humble wire coat hanger into something quite special. It is easy to achieve a neat finish working cross stitch on gingham. I used a section from the edge of an old napkin for a border, but you could use ribbon or lace. For a finishing touch, wind a piece of ribbon around the hook of the hanger.

materials

Template and stitch guide on page 101

5 ½ x 34 ½ in. (14 x 86 cm) gingham fabric

2 strips of fabric 17 in. (43 cm) in length and at least 1¾ in (4.5 cm) wide, for border

Stranded embroidery floss (cotton) in 2 contrasting colors

1 Enlarge the template on page 101 by 200 percent (see page 117), transfer to the gingham fabric, and cut out two hanger shapes. Using the stitch guide on page 101, center the cross stitch design on the front panel and stitch the pattern onto the fabric (see page 122). Turn over a small hem at the top edge of the front panel. Pin and machine stitch. Repeat on the back panel.

2 With right sides together, aligning the raw edges, pin the two border strips along the bottom edges of the front and back panels. Pin and machine stitch. Trim the seams and zigzag stitch the raw edges.

3 With right sides together, pin down each side edge of the cover and machine stitch. Do not stitch the top edge, as this is where the hanger hook will go. Trim the seams, turn right side out, and press.

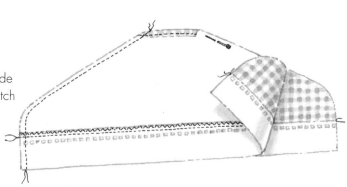

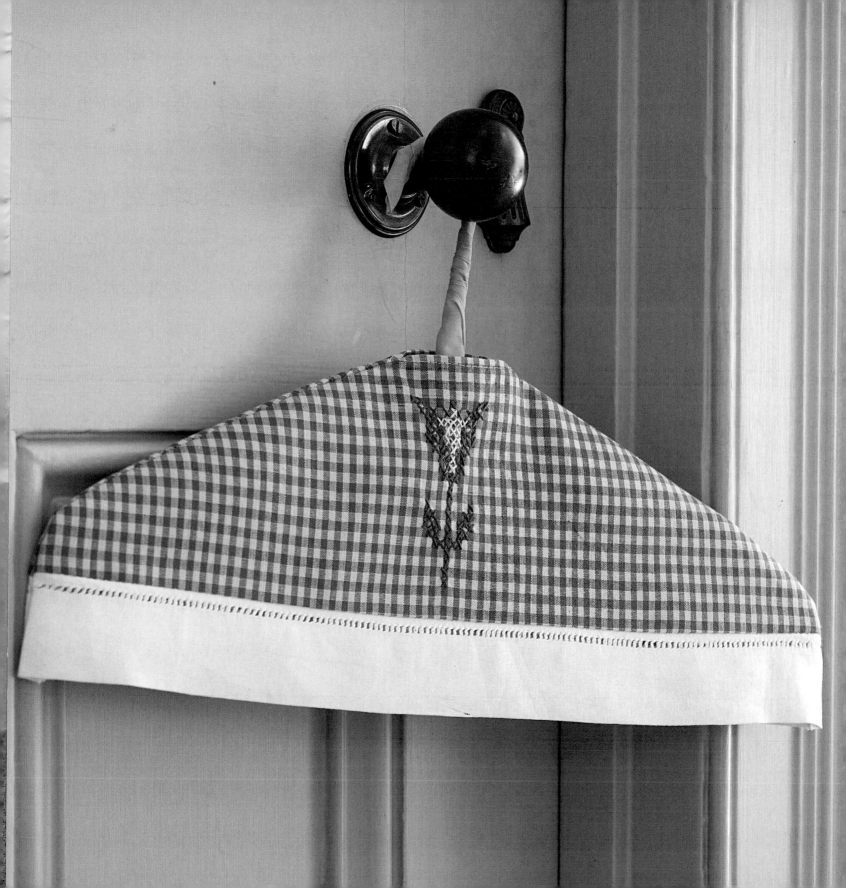

6 With right sides together, pin and machine stitch the inner legs to the two body pieces along the side and bottom edges.

7 With right sides together, pin the underbelly to the two body pieces, taking care at each end to finish the stitching in a point. Baste (tack) and machine stitch, leaving a gap in the seam at the top of one of the front legs to turn the reindeer right side out.

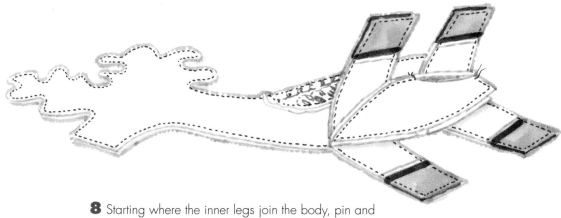

8 Starting where the inner legs join the body, pin and machine stitch the front and back together. Match up the line of stitching and carry on around, taking particular care on the curves of the antlers.

9 Starting with the antlers, turn the reindeer right side out. Use the handle of a long, thin paintbrush to help ease the tips of the antlers out. Stuff the toy, using the paintbrush handle to get the stuffing right up to the ends of the antlers and taking care to keep the stuffing firm at the top of the legs.

10 Turn under the raw edges at the gap in the front leg seam and slipstitch the gap closed (see page 120).

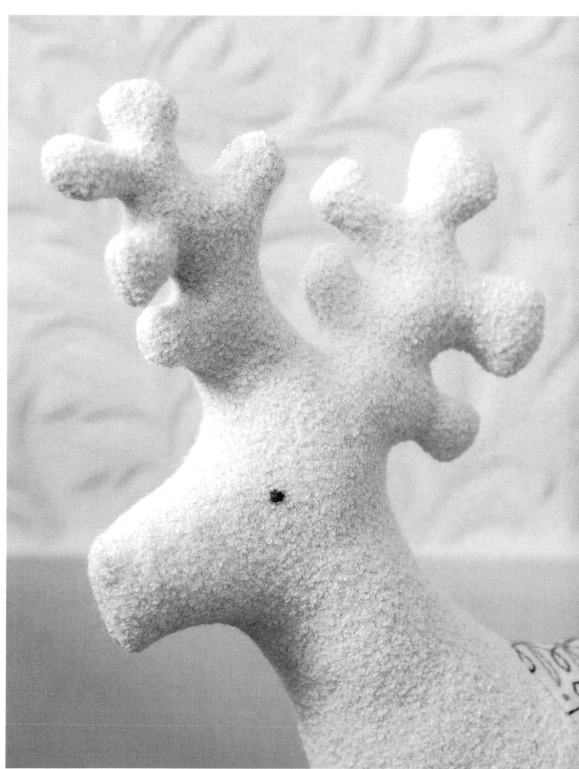

tree treasures

White painted twigs are a pretty and contemporary-looking alternative to the traditional Christmas tree. These felt decorations, simply stitched in a mix of blues and greens, make a stylish and festive collection.

materials

Templates and stitch guides on page 103

White or cream felt

Pale blue felt

Fade-away marker pen

Blue, green, and white stranded embroidery floss (cotton)

Pale gray satin ribbon, ¼ in. (5 mm) wide

1 Each decoration is made up of a front in white or cream felt and a back in pale blue felt. Enlarge the templates on page 103 by 200 percent (see page 117). Trace them onto felt (see page 118), and cut out as many pairs as you need.

2 Using the stitch guides on page 103 and a fade-away marker pen, draw the embroidery patterns on each felt shape.

3 Using blue, green, and white embroidery floss (cotton), embroider the motifs. Place the felt shapes together in pairs, right sides facing outward.

4 To make the loops, cut 8-in. (20-cm) lengths of pale gray satin ribbon. Fold each piece in half lengthwise and sandwich the raw ends in the top of the paired-up shapes. Pin in place and machine stitch across, stitching through all layers, to secure.

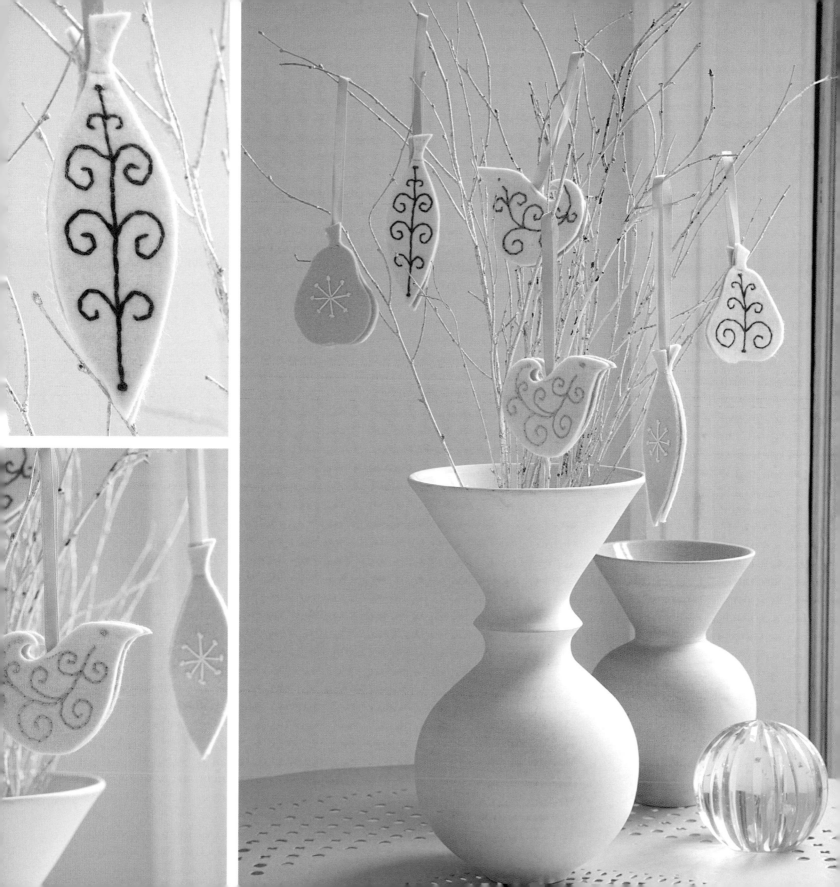

christmas stockings

Hanging out the Christmas stocking is a tradition that children everywhere look forward to, and these stockings in traditional red and white are special enough to become family heirlooms, bulging with presents on Christmas morning. These instructions are for the appliquéd and embroidered reindeer stocking. For the snowflake and heart designs, use the stitch guides on page 102 for the embroidery and make up the stockings following the instructions below.

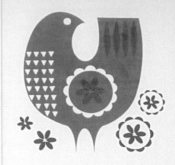

1 Enlarge the stocking template on page 102 by 250 percent (see page 117). Trace it onto the red fabric (see page 118), and cut out the front and back of the stocking.

2 Enlarge the reindeer template on page 102 by 250 percent. Trace it onto cream felt and cut out. Pin the reindeer in position on the front of the stocking. Following the stitch guide on page 102, embroider the stitches on the reindeer. You do not need to sew around the very edges of the felt, as the decorative stitches secure it in place. Using running stitch, sew the trail.

materials

To make one reindeer stocking

24-in. (60-cm) square of red felt or woollen fabric

7 x 9½ in. (18 x 24 cm) cream felt for appliqué

Templates and stitch guides on page 102

Red and white stranded embroidery floss (cotton)

18 in. (45 cm) black-and-white striped ribbon, 1½ in. (4 cm) wide

7 in. (18 cm) cream cotton tape or webbing for hanging loop

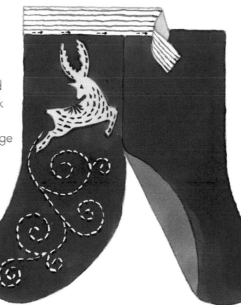

3 With right sides together, place the front and back of the stocking together. Pin down the back seam until you reach the curve. Open up the stocking and pin the ribbon all along the top edge on the right side, overlapping the top by about ½ in. (1 cm). Machine stitch close to the bottom edge of the ribbon to attach it to the stocking.

4 Trim the ends of the ribbon level with the edges of the stocking. With right sides together, fold the stocking back in half and machine stitch all around the sides, ½ in. (1 cm) from the edge. Trim the seam allowance to ¼ in. (5mm) and turn the stocking right side out.

5 Fold the cotton tape or webbing in half lengthwise and pin it inside the stocking at the top of the back seam, leaving about 2 in. (5 cm) sticking up above the top of the stocking. Machine stitch a line of zigzag stitches across the raw edges of the tape and just below the top edge of the ribbon to make the hanging loop. Press.

folk bird garland

Hang this pretty garland above a table or along a mantelpiece to add some home-spun, Scandinavian folk charm to your interior. This project gives you the opportunity to practise simple stitches to great effect. The measurements are for a garland 1 yard (1 m) long. To make a longer version, simply add more birds and leaves and a longer ribbon.

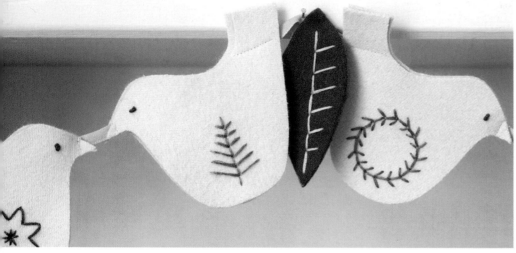

materials

Templates and stitch guides on page 103

20 x 17 in. (50 x 43 cm) pale gray felt

9½ x 7 in. (24 x 18 cm) green felt

Fade-away marker pen

Pale gray, blue-gray, and fawn stranded embroidery floss (cotton)

1 yd (1 m) pale gray ribbon, ½ in. (1 cm) wide

1 Enlarge the templates on page 103 by 200 percent (see page 117). Trace them onto felt (see page 118) and cut out 20 bird shapes and 12 leaf shapes. Pair up the shapes to make 10 birds and 6 leaves.

2 Using a fade-away marker pen, draw the embroidery motifs on the felt shapes. Using the stitch guides on page 103, embroider one motif on each bird and leaf.

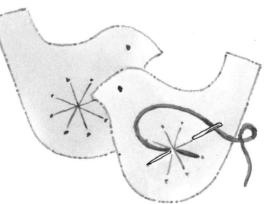

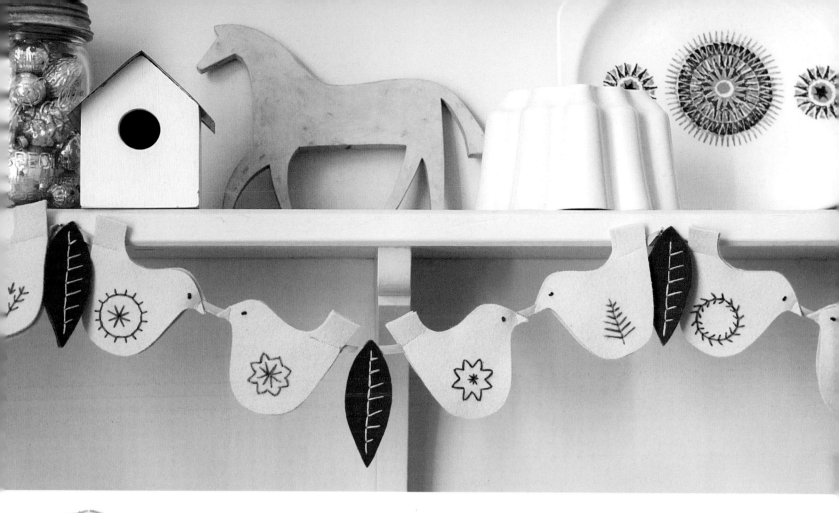

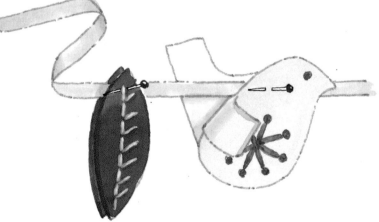

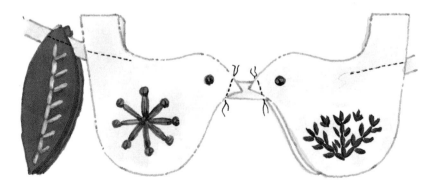

3 Sandwich the length of ribbon between the top sections of each pair of birds and leaves. Start with a leaf and then two birds facing each other, with beaks almost touching. Leave a gap of about ½ in. (1 cm) between each pair of motifs.

4 Machine stitch a short line across each pair of motifs at the beak and tail and the top of the leaf to secure, making sure that you catch the ribbon in the stitching.

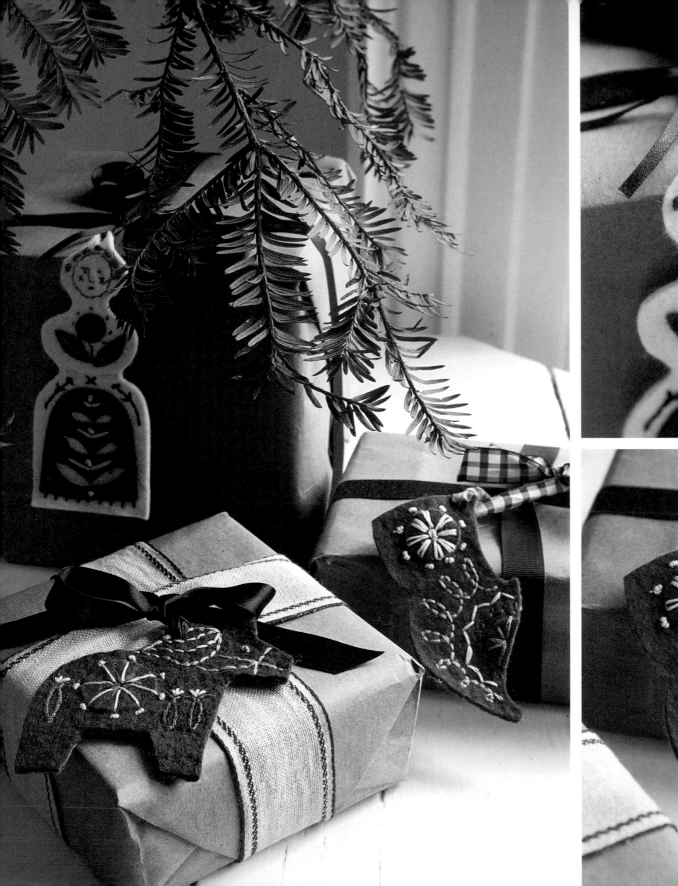
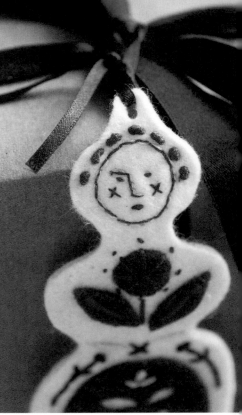
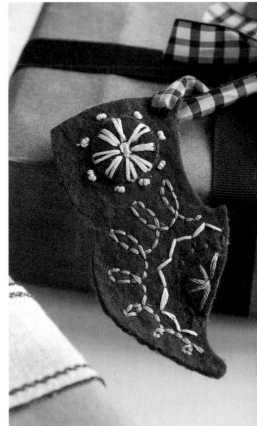

embroidered gift tags

These embroidered gift tags are based on traditional Swedish folk-art motifs. They may seem rather elaborate for labels, but they can be hung on the Christmas tree to be enjoyed year after year. Mix and match the colors for the felt and the stitches. There is no set pattern—just choose combinations that you like.

materials

Templates and stitch guides on page 101

Small pieces of red, green, pink, and cream felt

Small pieces of thin card

Brightly colored stranded embroidery floss (cotton)

Fabric glue

Lengths of ribbon, ⅛ in (3 mm) wide, for hanging loops

1 Enlarge the tag templates on page 101 by 200 percent (see page 117). Trace them onto felt (see page 118) and cut out. Cut pieces of thin card to match the tags. Hold the card and felt tag shapes together and cut or punch a hole for the ribbon at the top of each one.

2 Set the card shapes to one side. Place the cut-out felt pieces on the tags. You do not have to sew them down, as the embroidery over the top holds them in position. Using the stitch guides on page 101, embroider each tag.

3 Using fabric glue, stick the card shapes to the back of the corresponding felt tag shapes, making sure that the holes for the ribbon align.

4 Cut small lengths of ribbon. Thread the ribbon through the hole in each tag and tie a knot to make a hanging loop.

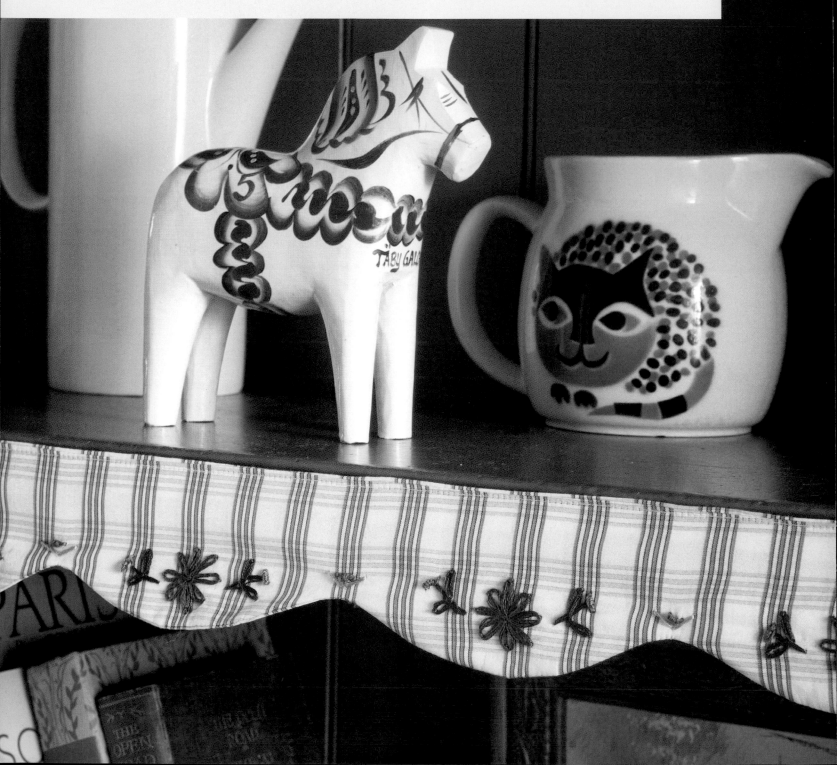

embroidered shelf edging

I love the clean lines of checks, stripes, and natural fabrics used in Scandinavian interiors. For this shelf edging I chose a crisp cotton fabric in bright blue and green checks. With its pretty scalloped edge and understated embroidery, it strikes a happy balance between old-fashioned country charm and stylish modernity, and will add a cheerful, homely look to a contemporary kitchen.

materials

Template and stitch guide on page 104

Thin card

Fade-away marker pen

Two strips of cotton fabric, 3¼ in. (8 cm) wide, length as desired

Blue and green stranded embroidery floss (cotton)

1 Enlarge the template on page 104 by 200 percent (see page 117). Trace the scallop shape onto a piece of card and cut out to make a template. Place the template on one long edge of the first fabric strip and, using a fade-away marker pen, draw around it, moving it along as often as needed until you reach the end of the strip. Cut out the scallop-shaped edge, then repeat on the second fabric strip.

2 Following the stitch guide on page 104, embroider the flower motifs along the scalloped edge, positioning each one in the middle of a scallop.

3 With right sides together, pin the border pieces together. Starting and finishing ½ in. (1 cm) from the end, machine stitch all along the scalloped edge, ½ in. (1 cm) from the edge. Trim the seam allowance to ¼ in. (5 mm), and cut tiny V-shaped notches into the seam allowance so that the fabric will lie flat, making sure that you do not cut through the stitching.

4 Turn the border right side out, easing the scallops into shape. Press, taking care on the curves.

5 Turn in a ½-in. (1-cm) hem on the top and side edges. Press, pin, and machine topstitch, stitching as close to the edge of the fabric as possible.

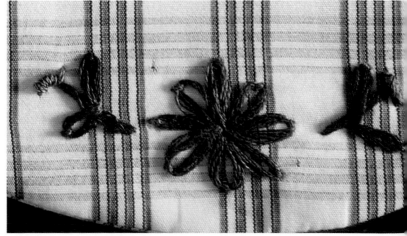

apron

Hang this apron on a hook or on the back of a door to bring a bit of Scandinavian chic to your kitchen. I used a striped linen, but ticking could also work well, especially in a red stripe to contrast with the denim. I decided to use a herring motif on the pocket design; it forms part of many traditional Scandinavian dishes, so is perfect for cooking in.

materials

Templates and stitch guide on page 105

40 x 40 in. (100 x 100 cm) striped linen

Tailor's chalk

11¼ x 16½ in. (28 x 41 cm) denim for pocket

Dressmaker's carbon paper

White sewing thread

2½ x 2 in. (6.5 x 5 cm) red felt for label

White stranded embroidery floss (cotton)

1 For the apron cut a piece of fabric measuring 40 x 29 in. (100 x 72.5 cm). Fold in half lengthwise. On the top edge measure out 5½ in. (14 cm) from the fold and mark with a pin. From the bottom edge measure up 28 in. (70 cm) and mark with a pin. Using tailor's chalk, draw a curved line to join the two pins (see illustration on left for angle of curve). Cut through both thicknesses of the fabric and unfold. Fold over a ½-in. (1-cm) double hem on the bottom edge, pin, and machine stitch. Repeat with the top and curved side edges, making sure the hem is flat, then stitch the straight side edges in the same way.

2 Using light-colored dressmaker's carbon paper, transfer the design on page 105 to the denim pocket piece (see page 118). Machine stitch the design, using a tight zigzag stitch.

3 Fold the red felt for the label in half widthwise. Stitch a small circle of bullion knots (see page 123) in the top half of the label, placing it close to the fold line. With right sides together, machine stitch down each short side of the label and turn right side out.

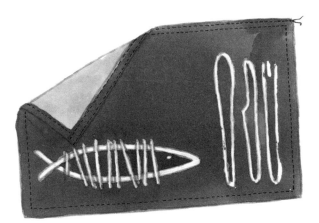

4 Fold over ½ in. (1 cm) to the wrong side all around the edges of the pocket piece, and pin in place. Machine stitch all around, ½ in. (1 cm) from the edge, then stitch another line along the top edge only, as close to the edge as possible.

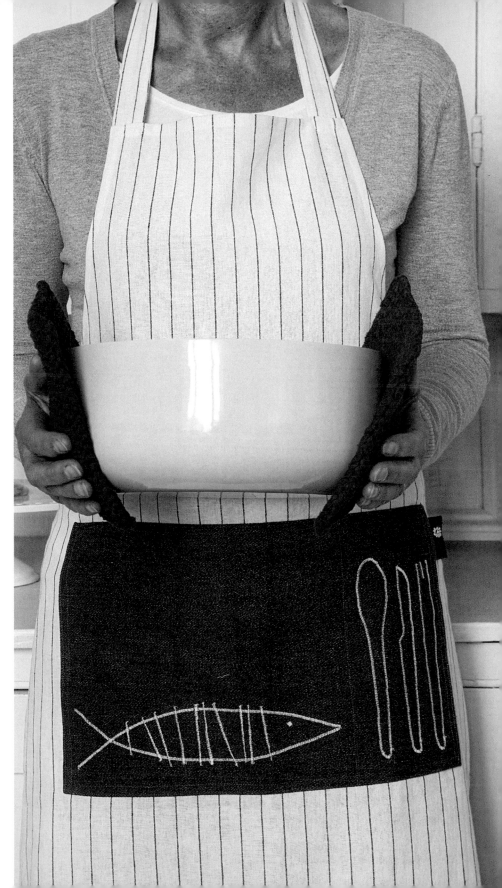

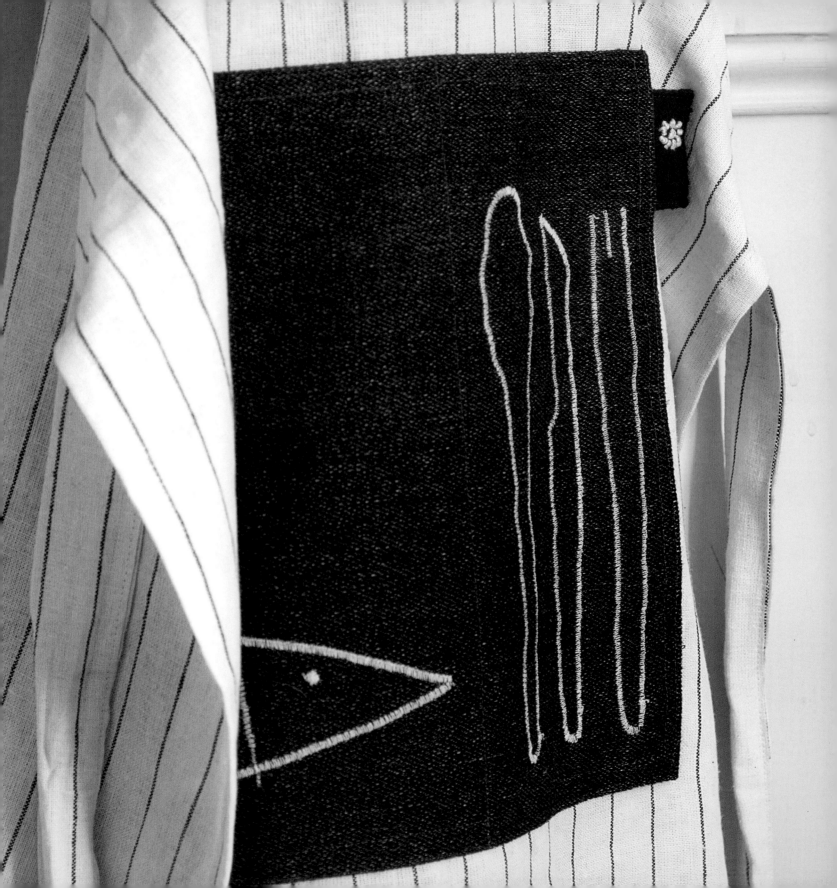

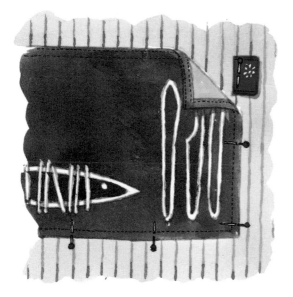

5 Pin the pocket on the apron, tucking the label under the right-hand edge of the pocket, ½ in. (1 cm) from the top, with the raw edges facing inward. Machine stitch along the two sides and base of pocket, close to the edge, so that you have formed a double row of stitches. Machine stitch from the top to the bottom of the pocket, in between the fish and the cutlery, to create a divide in the pocket.

6 For the ties, cut two 4 x 28-in. (10 x 70-cm) oblongs of striped fabric. Fold each one in half widthwise, wrong sides together, and press. Open out, then press under ¾ in. (2 cm) along each long edge. Fold in the raw edges at each short end of the strip and press, then re-fold along the center crease. Pin, then machine stitch around the three unfolded sides, stitching as close to the edge as possible, Place on the apron, flush with the side hem, then stitch all around in a rectangle and finally from corner to corner. Sew the neck piece in the same way. Press the finished apron.

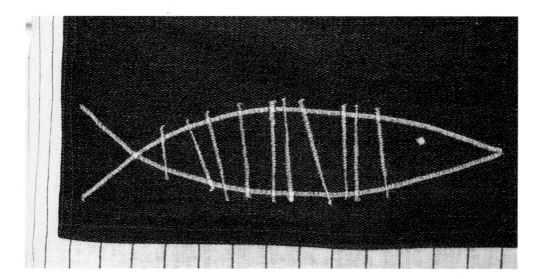

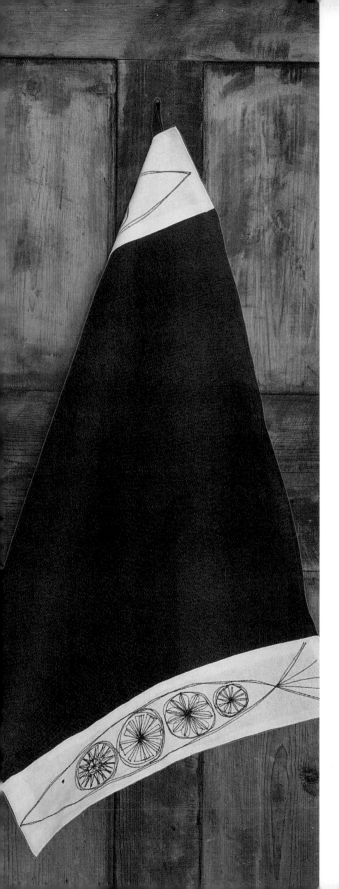

blue herring tea towel

I love Scandinavian ceramics from the 1950s and '60s and have taken my inspiration for this simple embroidered tea towel from the wonderful mix of abstract pattern and bright colors that appear in the designs. Herring is a national dish and is worked here in blues and greens on white set against vibrant blue linen.

1 The template for the fish design on page 105 is split in two—one for the blue stitching and one for the green. Enlarge it by 200 percent (see page 117). Using dressmaker's carbon paper, transfer one of the color templates to each cream linen rectangle. One fish should face to the left and one to the right.

2 Set your sewing machine to a thin, close zigzag and stitch the first color of fish motif onto the two pieces of linen. It does not matter if you don't go over the lines exactly: the design is meant to look as if it has been drawn loosely with a pen. Repeat for the second color of stitching.

3 To make a tab, press the small blue linen rectangle in half widthwise, wrong sides together, then press under ½ in. (1 cm) along each long edge and refold. Pin the edges together, and then machine stitch around the unfolded edges, ⅛ in. (3 mm) from the edge.

materials

Templates on page 105

Dressmaker's carbon paper

30 x 19 in. (75 x 48 cm) blue linen

Two 4¾ x 19-in. (12 x 48-cm) pieces of cream linen

4¼ x 1¼ in. (11 x 3 cm) blue linen for the tab

Blue and green sewing thread

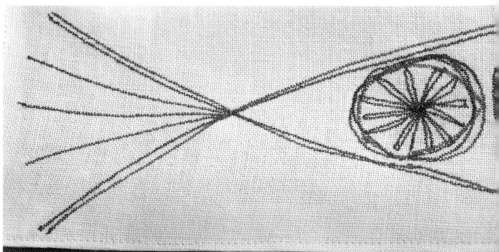

4 Turn a
single ¼-in.
(5-mm) hem over
to the right side at the top
and bottom of the blue linen rectangle.
Pin and machine stitch. Then turn under a
double ¼-in. (5-mm) hem along the side
edges. Pin and machine stitch.

5 Turn under and press a single ½-in.
(1-cm) hem along the top and bottom
edges of both fish panels. Pin the fish panels
to the top and bottom edges on the right
side of the tea towel, so that the edges are
flush. Turn in the hem at the side edges of
each fish panel, so that the borders are
flush with the hemmed edge of the tea
towel, and pin in place. Insert the loop into
the top right corner, sandwiched at a slight
angle between the main tea towel and the
fish panel. Machine topstitch around all
four sides of each fish panel, ⅛ in. (3 mm)
from the edge. Press.

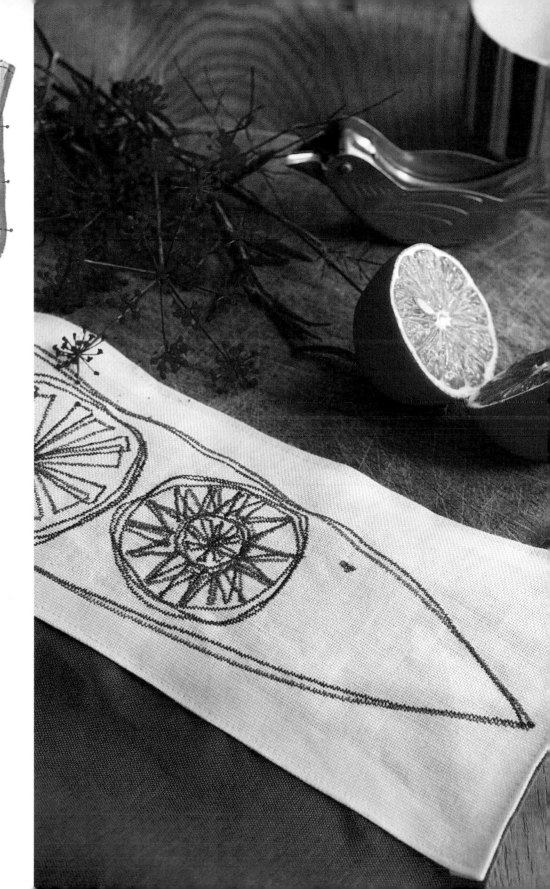

table runner

Table runners are a stylish alternative to tablecloths. This one is decorated with running stitch, the simplest of embroidery, but used to great effect here. I have chosen a deep indigo blue and matched the embroidery thread so that it contrasts well on the cream border. To fit your table, simply decrease or increase the length of the central panel.

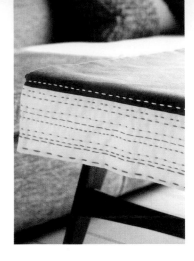

1 Using a ruler and fade-away marker pen, draw nine straight lines across the width of the two border panels. Vary the distance between each line by ¼, ½, or ¾ in. (5, 10, or 15 mm). Using running stitch (see page 121), sew along the lines. Vary the thickness of the stitches by using either all six strands of the embroidery floss (cotton) or by doubling it to 12 strands. Vary the length of the stitches and the spaces in between them with each line.

materials

Fade-away marker pen

Ruler

55 x 21 in. (138 x 53 cm) cotton or linen fabric

2 pieces cotton or linen in a contrasting color, each 5½ x 21 in (14 x 53cm)

61 x 21 in. (152 x 53 cm) cotton lining fabric

Stranded embroidery floss (cotton) to match central panel

Cream stranded embroidery floss (cotton)

2 Using cream stranded embroidry floss (cotton), sew one line of running stitch ¾ in. (2 cm) in from each short edge of the center panel. With right sides together, pin and machine stitch the border panels to the center panel. Press the seams flat.

3 Place the lining and outer panels right sides together. Pin and machine stitch all around the edge, leaving a 6-in. (15-cm) gap in one long side. Turn the table runner right side out. Fold in the seam at the gap and slipstitch it closed. Press.

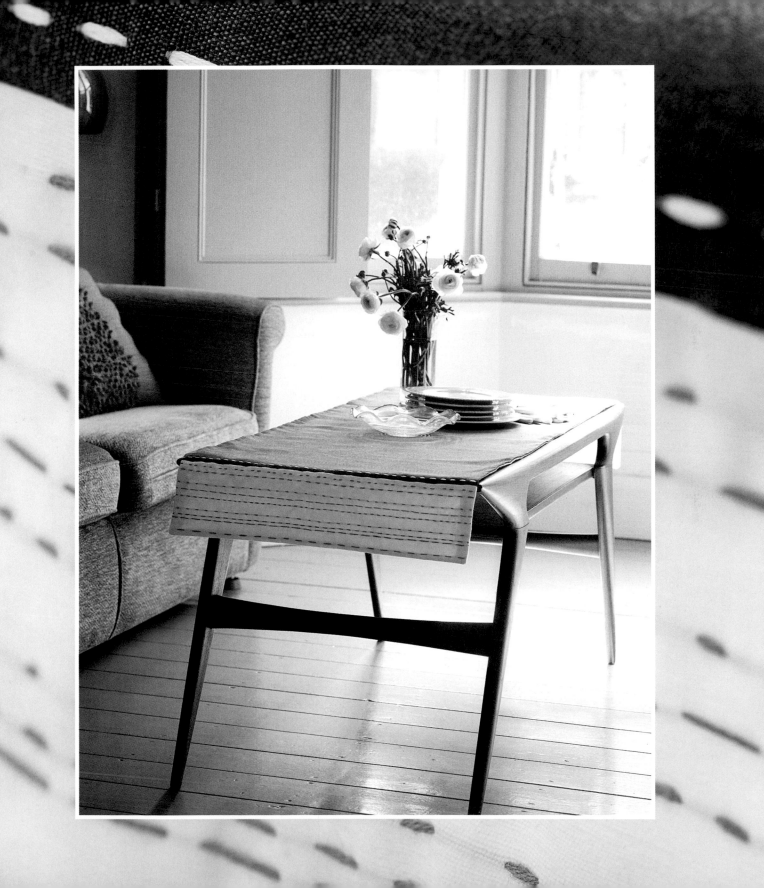

folk-heart egg cozies

It won't take long to make these endearing egg cozies. They are an ideal first project for anyone new to sewing, and make a quick gift idea for the more experienced needleworker.

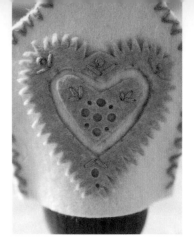

1 Enlarge the templates on page 104 by 200 percent (see page 117). Trace the motifs onto felt (see page 118) and cut out two egg cozy shapes from gray felt and two from cream felt. Cut out the cream and gray heart shapes.

2 To make the cut-out holes in the heart shapes, I used a hole punch that has different-sized heads and made holes 1⁄16 in. and 1⁄32 in. (2 mm and 1 mm) in diameter. If you do not have a hole punch, cut the holes with small scissors; the holes will be more like petal shapes than perfect circles, but they will work just as well.

3 The embroidery is very simple—just French knots and straight stitches. Chose one color of embroidery floss (cotton) for the gray cozy and a different color for the cream cozy. Embroider the stitches on the heart shapes, using the stitch guide on page 104.

materials

Templates and stitch guide on page 104

Fade-away marker pen

7 x 6 in. (18 x 15 cm) each of gray and cream felt

Eyelet or leather punch

Stranded embroidery floss (cotton) in two colors

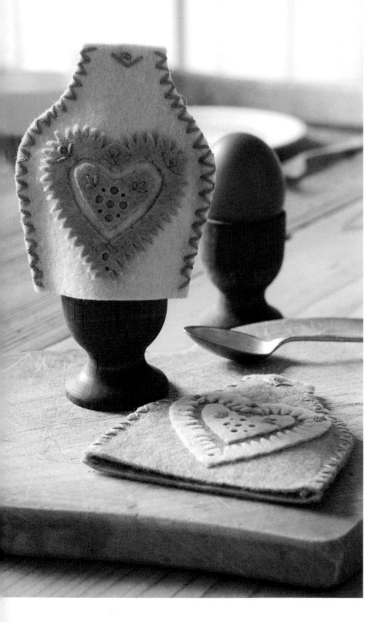

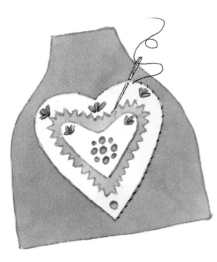

4 Pin the heart cut-outs onto one side of each egg cozy. Slipstitch the shapes in place.

5 Pin the front and back of the cozies wrong sides together. Following the instructions for the felted wool slippers (see page 56), work a decorative v-shaped stitch around the side edges and a v-shaped stitch and a French knot in the center of the top edge, stitching through both layers.

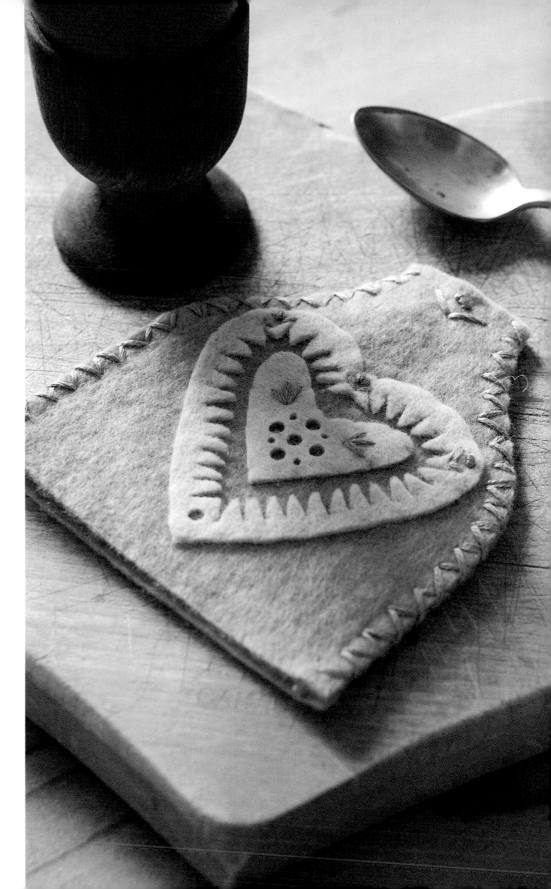

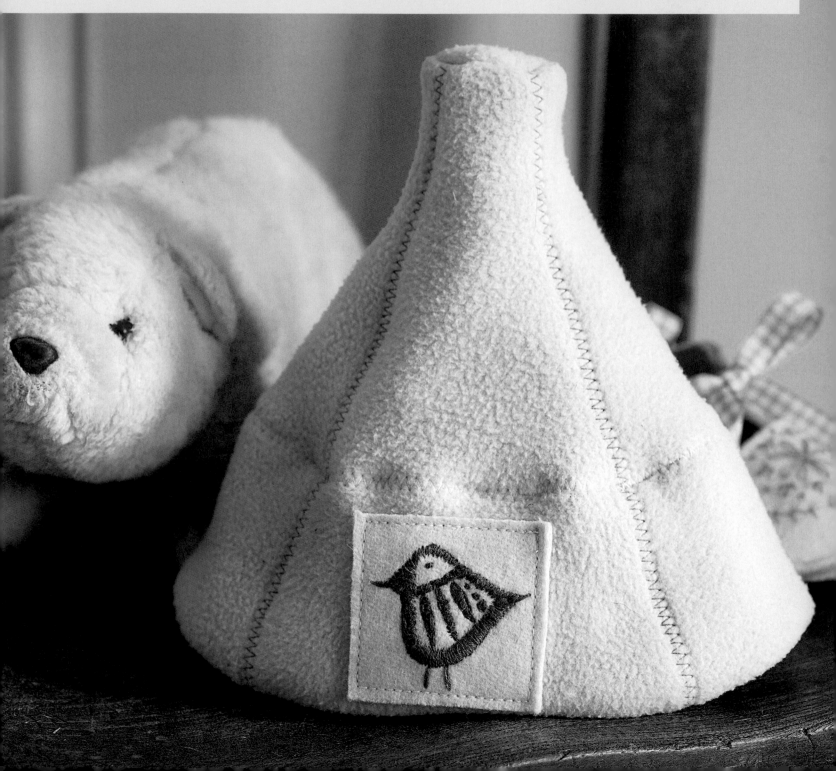

fleecy hat
This cozy little hat, made of soft fleece, is ideal for a baby. It has the added charm of two embroidered labels. The bird is a popular motif in both traditional and modern Scandinavian design.

materials

Templates and stitch guide on page 108

35½ x 5 in. (90 x 13 cm) pale blue fleece fabric

Dressmaker's carbon paper

Scraps of blue and white felt for labels

White and blue stranded embroidery floss (cotton)

1 Enlarge the templates on page 108 by 200 percent (see page 117), transfer onto the fleece fabric, and cut out. You will need four panels for the hat, plus one center circle.

2 Using dressmaker's carbon paper, transfer the embroidery motifs to the felt for the labels. Sew the snowflake design by sewing four straight stitches of equal length that cross over each other in the middle. Make one small stitch across the overlapping stitches in the middle and finish off with a French knot at each end of the stitches. Embroider the bird using satin stitch (see page 124).

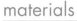
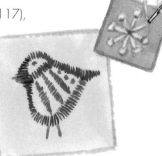

3 Pin and sew the labels in position on two of the hat panels, 2¾ in. (6.5 cm) up from the bottom edge and centered from side to side.

4 With right sides together, pin and machine stitch the four hat panels together, making sure that the panels with labels are opposite each other. Use stretch stitch if your machine has it. Turn the hat right side out and zigzag stitch over each seam in a contrasting color. Turn under a 2½-in. (6-cm) hem around the bottom edge. Pin and machine stitch. Zigzag stitch over the hem line using thread that is the same color as the fleece fabric.

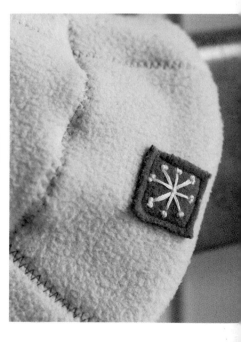

5 Turn the hat inside out. Pin and baste (tack) the small round piece to the center top of the hat. Machine stitch. Turn right side out.

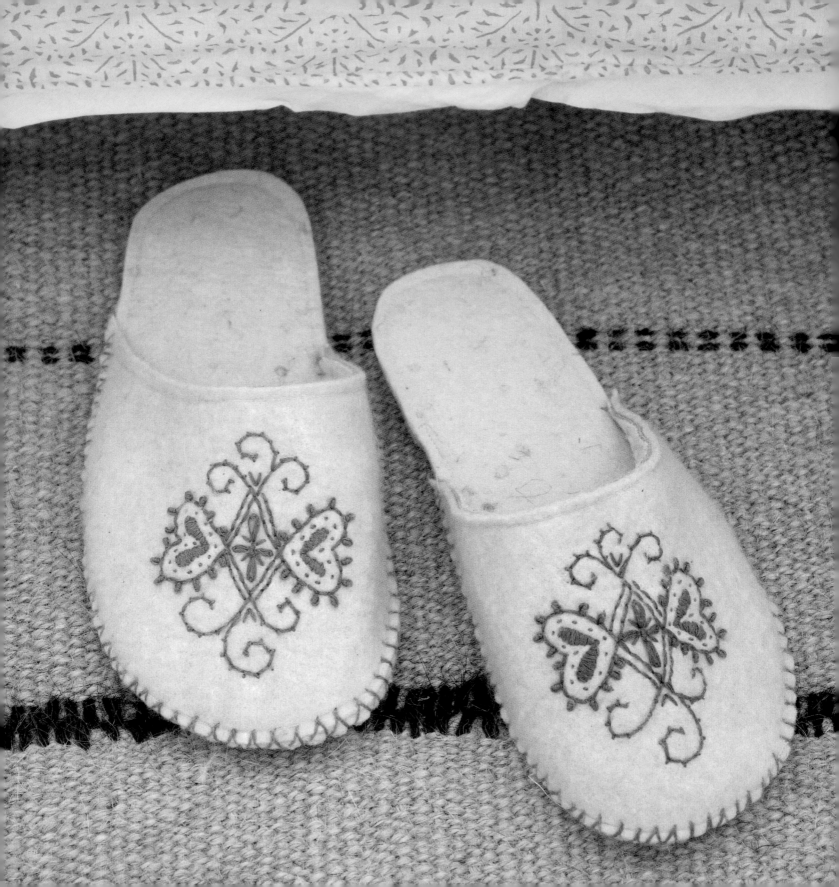

felted wool slippers

The oldest record of felt-making in Scandinavia dates back to the Iron Age, and felt was an essential part of everyday life for the nomadic tribes of the area, vital as insulation against the long, harsh winters. Traditionally, felt has been used in making jackets, hats, mittens, socks, and boots, as well as for soft furnishings such as rugs, blankets, and pillows. In recent years, designers have revived the interest in felt-making and, in today's Scandinavian homes, you may well find stylish and contemporary felt slippers that have their roots in an ancient tradition.

These felted wool slippers are incredibly snug and comfy. The embroidered design looks detailed, but can be done even by anyone new to embroidery as it is mostly made up of backstitch, satin stitch, and bullion knots. You can make your own felted wool for this project by taking a woollen sweater and boil washing it at the highest temperature your machine will wash at.

materials

For a pair of slippers approx. 9½ in. (24 cm) long:

Templates and stitch guide on page 107

Dressmaker's carbon paper

Approx. 12 x 16 in. (30 x 40 cm) cream felted wool

Approx. 8 x 12 in. (20 x 30 cm) cream fleece fabric

8½ x 11 in. (22 x 28 cm) suedette or chamois leather

Blue-gray stranded embroidery floss (cotton)

1 Enlarge the templates on page 107 to the desired size (see page 117). Starting with the left foot, cut out an upper and a sole from felted wool, an upper from fleece, and a sole from suedette or chamois leather. Turn the templates over and cut the same pieces for the right foot.

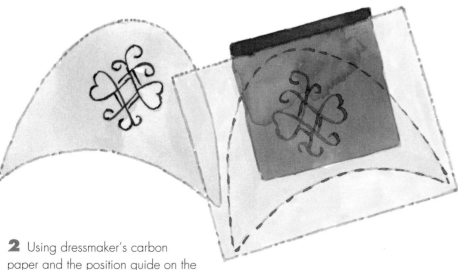

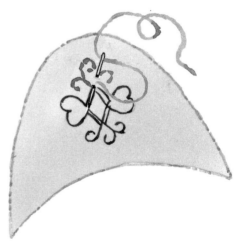

2 Using dressmaker's carbon paper and the position guide on the template (see page 107), draw the design on the left upper. Turn the template and position guide over and draw the design on the right upper.

3 Using the stitch guide on page 107, embroider the design on each slipper upper.

4 With wrong sides together, pin the felted wool and fleece uppers together. Machine stitch them together, stitching about ⅛ in. (3 mm) from the edge. Do the same for the felted wool and suedette soles.

5 Pin each upper section to the corresponding sole piece, easing it around the front curve of the slipper.

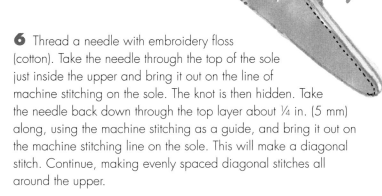

6 Thread a needle with embroidery floss (cotton). Take the needle through the top of the sole just inside the upper and bring it out on the line of machine stitching on the sole. The knot is then hidden. Take the needle back down through the top layer about ¼ in. (5 mm) along, using the machine stitching as a guide, and bring it out on the machine stitching line on the sole. This will make a diagonal stitch. Continue, making evenly spaced diagonal stitches all around the upper.

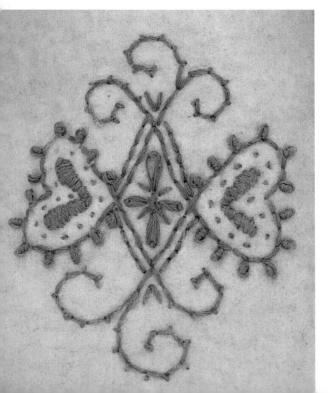

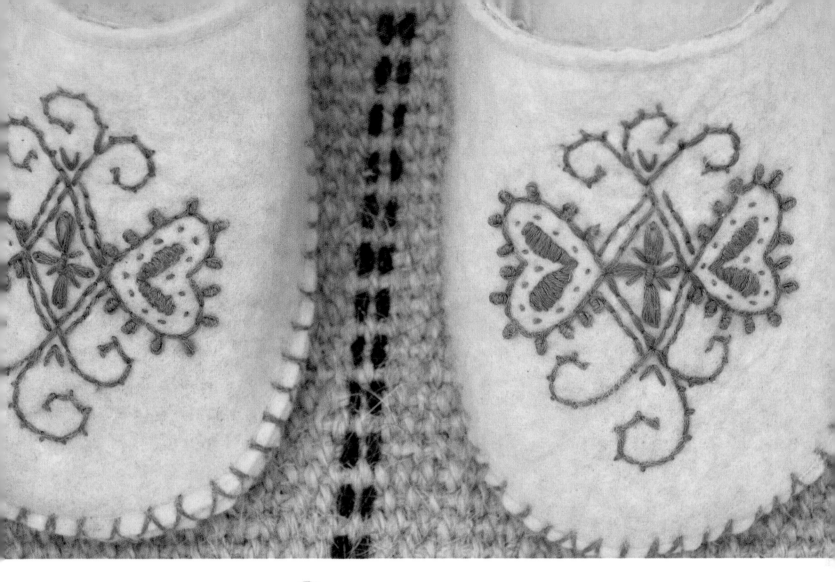

7 Work back around the upper in the opposite direction, taking the thread back through the holes of the first row of diagonal stitches so that they slant in the opposite direction and create a decorative v-shape.

button badges and cute clips

In this project you can go wild with your color choices; in fact, the brighter the better! Place pretty shaped buttons alongside vibrantly colored stitches to create cute badges or hair clips—fun decorations that cost practically nothing to make.

1 Enlarge the templates on page 104 by 200 percent (see page 117). Trace the shapes onto felt (see page 118) and cut out. I used 3 mm felt; if you can only find thin felt, use a double thickness. Draw the patterns on the felt shapes with a fade-away marker pen.

materials

Templates and stitch guides on page 104

Small pieces of thick felt in bright colors

Fade-away marker pen

Stranded embroidery floss (cotton) in bright colors

Buttons in pretty shapes

Safety pins and/or hair clips

2 Using the stitch guides on page 104, embroider the patterns in brightly colored embroidery floss (cotton).

3 Sew buttons on to decorate.

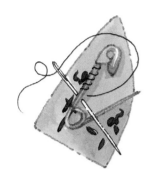

4 Sew safety pins to the back of the shapes you want as badges and simple hair clips to the ones you want as hair decorations, making sure that the needle does not go through to the front of the badge, as the stitching will show.

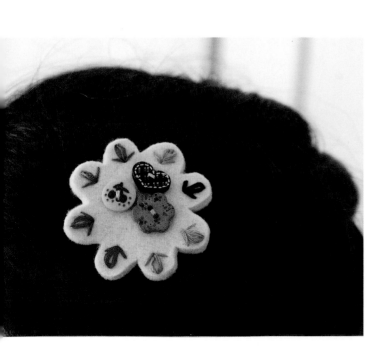

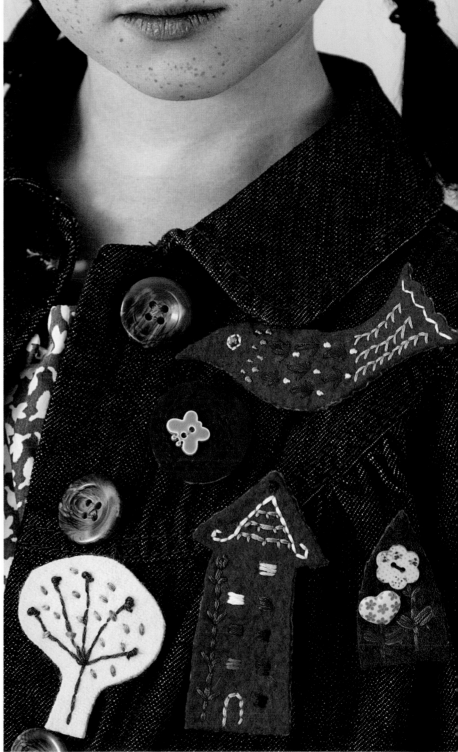

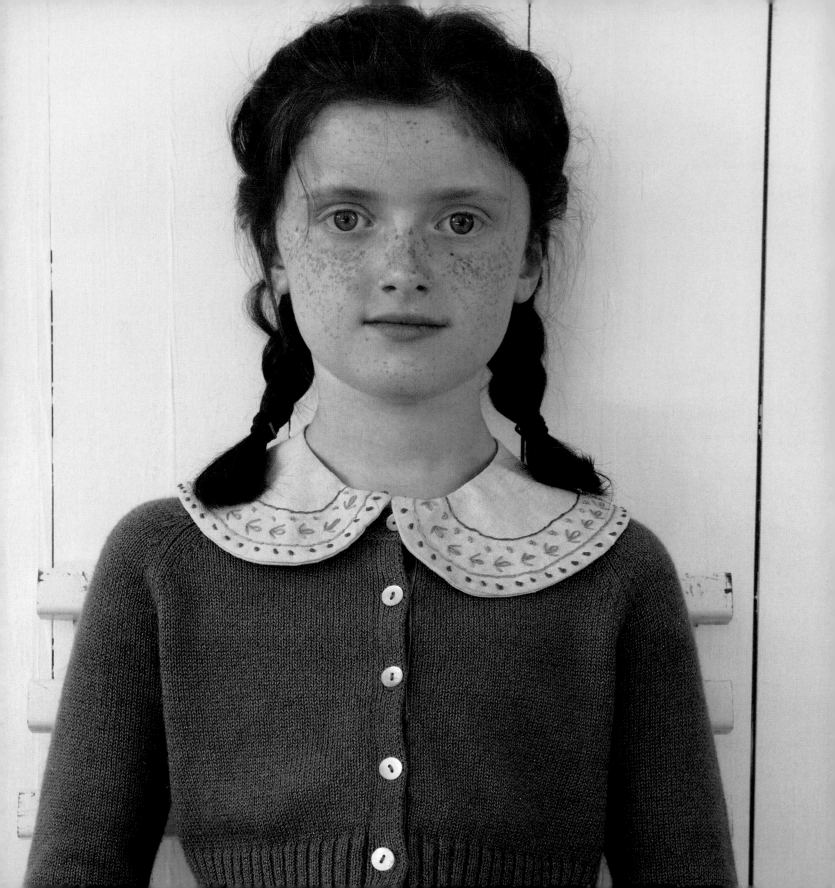

embroidered linen collar

There is a love and appreciation of natural fabrics in Scandinavia. I use linen in many of my projects, as the fabric sums up the principles of Scandinavian design—the combination of function and beauty. Worn over a plain round-necked sweater or cardigan, this timeless Peter Pan collar turns a simple outfit into something quite special.

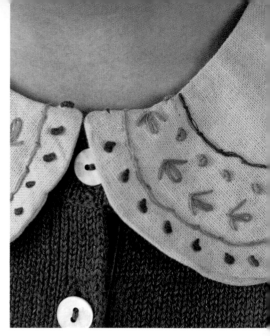

1 Enlarge the template on page 108 by 200 percent (see page 117). (To change the size of the collar, decrease or increase the length at the center, which is marked with a dotted line on the template.) Transfer the template to the linen fabric (see page 118) and cut out one back and one front piece.

2 Using dressmaker's carbon paper and the stitch guide on page 108, mark out two lines on the front piece of the collar. Using green embroidery floss (cotton) for one line and blue for the other, stitch each line in coral stitch (see page 123).

materials

Templates and stitch guide on page 108

Dressmaker's carbon paper

Fade-away marker pen

Approx. 13½ x 20 in. (34 x 50 cm) linen fabric

Blue and green stranded embroidery floss (cotton)

Small hook-and-eye fastening

3 Using the coral stitch lines as guides, mark the other stitches with a fade-away marker pen, spacing them evenly. Embroider them, using blue and green embroidery floss (cotton), as you choose.

4 With right sides together, pin the back and front of the collar together. Machine stitch all around, taking a ½-in. (1-cm) seam and leaving a 4-in. (10-cm) gap in the center of the neck edge.

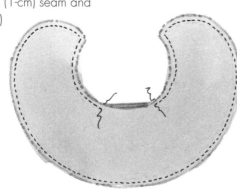

5 Trim the seam allowance to ¼ in. (5 mm). Turn the collar right side out, easing it into shape. Turn in the raw edges of the gap in the seam, pin in place, and slipstitch the gap closed (see page 120). Sew a hook-and-eye fastening at the front corner points to finish. Press.

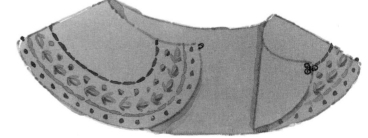

materials

Template and stitch guide on page 109

Dressmaker's carbon paper

Approx. 50 x 14 in. (130 x 35 cm) gray soft wool fabric

White and yellow stranded embroidery floss (cotton)

floral winter scarf

When we think of typical Scandinavian colors, we tend to think of red and white—but the muted gray, white, and yellow used here are also very traditional. I used a soft wool fabric, but you could use fleece—or even linen for a more lightweight scarf.

1 Fold the wool fabric in half widthwise, wrong sides together, and pin to secure. Enlarge the template on page 109 by 133 percent. Using dressmaker's carbon paper, transfer the design to each short end of the wool fabric, 1 in. (2.5 cm) from the short edge and centered on the width. Make sure that the stalk is at the bottom of the design at both ends.

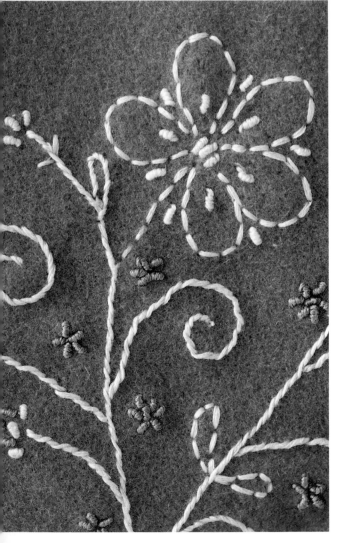

2 Following the stitch guide on page 109, embroider the flower design. Wind the embroidery floss (cotton) four times around the needle instead of the usual three, to make the yellow bullion knots slightly longer than normal.

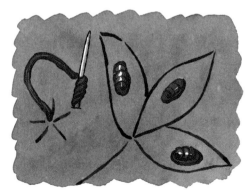

3 Fold the scarf in half widthwise, right sides together. Pin around all three raw edges about ½ in. (1 cm) from the edge. Machine stitch, leaving a 4½-in. (12-cm) gap in the middle of the long side.

4 Cut across the corners and trim the seam allowance to ¼ in. (5 mm). Turn the scarf right side out, easing out the corners. Slipstitch the gap closed. Press.

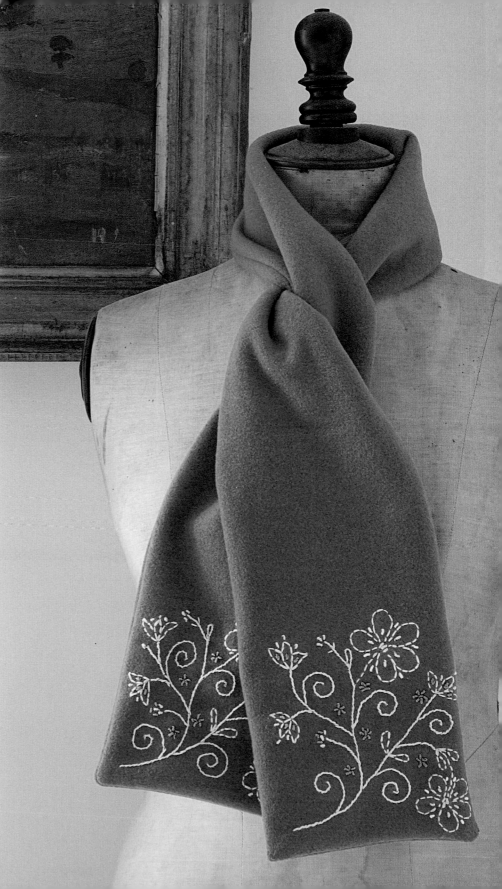

sami felt mittens

These felted wool mittens, with their vibrant embroidery and colorful pompoms, were inspired by the handicrafts of the nomadic Sami people, who have inhabited the northern areas of Scandinavia since ancient times. For the Sami, everyday items had to be functional but also beautiful; items of clothing were traditionally embroidered with rich, colorful pattern work.

materials

To fit ages 7–10

Template and stitch guide on page 109

22 x 8½ in. (56 x 21 cm) felted wool

Dressmaker's carbon paper or tissue paper

Knitting or tapestry yarn in bright colors

1 Enlarge the template on page 109 by 133 percent (see page 117), trace it onto felted wool (see page 118), and cut out one front and one back piece for each mitten.

2 Using dressmaker's carbon paper or the tissue paper and basting (tacking) method (see page 118), transfer the embroidery motif to the front section of each mitten. Following the stitch guide on page 109, embroider the pattern in the colors of your choice. Start by outlining the stem, leaves, and main flower, then fill in the leaves and petals with satin stitch.

3 The center of the flower motif on the cuff consists of tufts of wool similar to a candlewick stitch. Using straight stitch, sew an eight-pointed star shape, making each stitch about ¼ in. (5 mm) long, with each point of the star consisting of three stitches on top of each other.

4 Snip the outer ends of each point and fluff up the strands of yarn into a nice, rounded cushion shape. Complete the cuff embroidery.

5 Following the instructions on page 124, make two pompoms for each mitten.

6 Pin the back and front sections right sides together, sandwiching the long woollen strands on the pompoms between the two layers, about 1 ½ in. (4 cm) up from the bottom edge, opposite the thumbs. Machine stitch the back and front sections together, taking a ¼-in. (5-mm) seam. Snip into the curve of the thumbs, so that the fabric lies flat. Turn the mittens right side out and press.

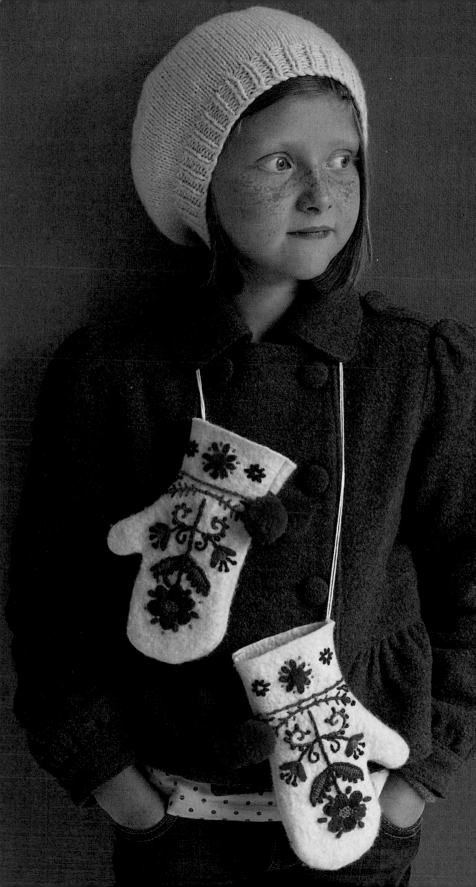

felt baby boots
Everyone who sees these little boots falls in love with them. They would make a wonderful present for a baby. As an extra-special gift, why not get have the baby's name embroidered on labels? You can order them in small quantities and they add a lovely personal touch, as well as that all-important designer finish. When the baby has grown out of the boots, they look delightful displayed on a shelf in the child's bedroom.

materials

Templates and stitch guide on page 106

Dressmaker's carbon paper

12½ x 8¾ in. (31 x 22 cm) felt

12½ x 8¾ in. (31 x 22 cm) fleece for lining

Stranded embroidery floss (cotton) in contrast color

Name tag (optional)

1 Using the templates on page 106, cut two uppers, one left sole, and one right sole from both the felt and the fleece fabrics. Using dressmaker's carbon paper and the pattern on page 106, transfer the design onto the felt uppers (see page 118). Following the stitch guide on page 106, embroider the design (see page 106). Next, place the fleece and felt uppers wrong sides together. Fold in half, with the felt on the inside. Pin down the back seam. Insert a label if you plan to use one. If the rim of the finished boot is to stand up, place the label ¼ in. (5 mm) down from the top edge, facing in toward the center (as shown). If the rim is to be turned over, have the label facing outward with the text upside down. Machine stitch the back seam, stitching ¼ in. (5 mm) in from the edge.

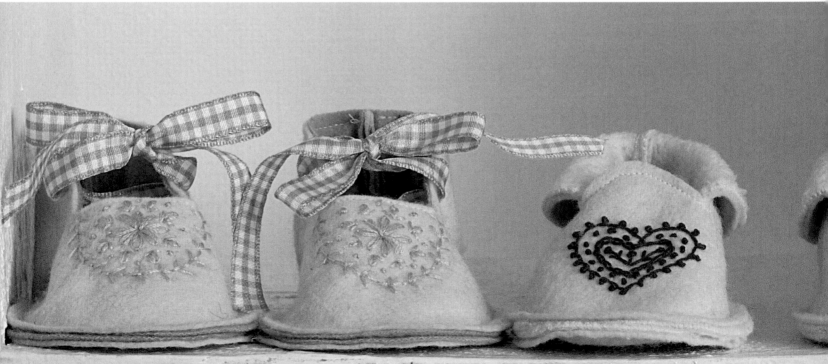

2 Turn the boot upper right side out. Place the lining and outer sole pieces wrong sides together. Starting at the center front of the boot, pin the upper pieces to the sole pieces. Baste (tack) together, and sew a seam ¼ in. (5 mm) in from the edge.

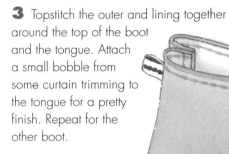

3 Topstitch the outer and lining together around the top of the boot and the tongue. Attach a small bobble from some curtain trimming to the tongue for a pretty finish. Repeat for the other boot.

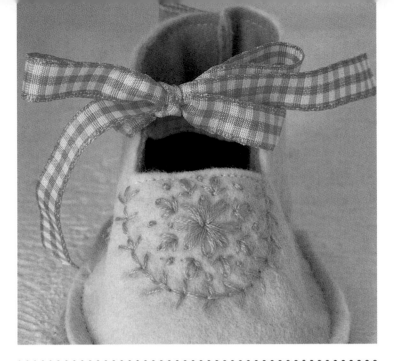

For a variation, when you cut out the templates, trim away the tongue from the upper and add ½ in. (1 cm) to the height of the boot sides. Once the label is inserted (see Step 1), fold the boot sides over. Alternatively, make a hole in each of the side flaps and thread through some ribbon for a tie.

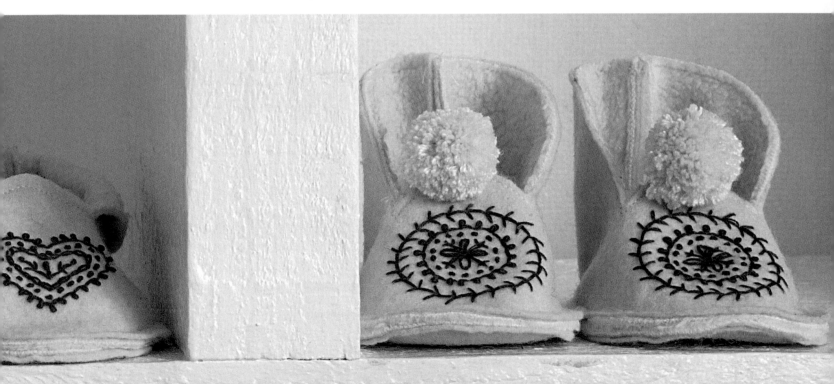

sampler linen dress

The traditional crafts of embroidery, weaving, and lacemaking have their roots in the everyday lives of rural Scandinavians. Patterns and motifs were used to decorate clothes, wall hangings, bed covers, pillows, and other ordinary articles in the home. This dress, in traditional red and white, is simple in design but stunning. The stitches are not difficult and are worked in lines reminiscent of an embroidered sampler. Made of thick linen, this can be handed down from one child to another and will always be a favorite.

materials

To fit ages 6–7

Templates and stitch guide on page 110

Approx. 1 yd (1 m) white linen

Approx. 4½ x 18¾ in. (11 x 48 cm) striped linen for the border

Approx. 16 x 16 in. (40 x 40 cm) cotton fabric for facings

Fade-away marker pen

Red stranded embroidery floss (cotton)

18¾-in. (48-cm) length of lace, ¾ in. (2 cm) wide

1 x ¾-in. (2-cm) button

1 Enlarge the templates on page 110 to the required size (see page 117) and trace onto a large piece of paper, such as newspaper. Cut out. Pin the paper pattern pieces to the fabric. Cut one front piece, two back pieces, two straps (each 8 x 2¾ in. [20 x 7 cm]), and one loop from white linen, and one border panel from striped linen. Cut one front and one back facing from cotton fabric.

2 Following the template on page 110 and using a fade-away marker pen, draw lines at the top of the dress to guide your stitching. Following the stitch guide on page 110, using red embroidery floss (cotton), embroider the top of the dress.

3 Following the stitch guide on page 110, using red embroidery floss (cotton), embroider the striped linen border. Use the stripes of the border fabric to keep your stitching straight.

4 Press the strap rectangles in half widthwise, wrong sides together. Open the straps out again, press the long edges to the wrong side by ½ in. (1 cm), and re-fold along the center crease. Pin and machine stitch along the long, unfolded edge, ⅛ in. (3 mm) from the edge.

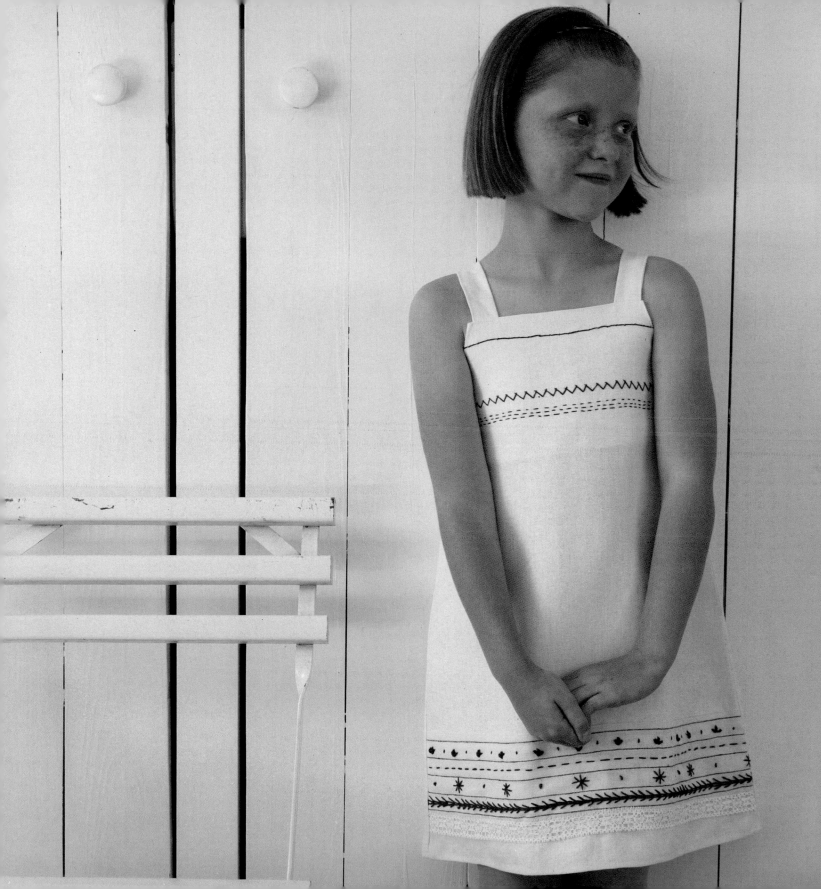

6 Along the top and bottom of the striped border fabric, turn under ½ in. (1 cm) to the wrong side, and press. Pin the length of lace along the bottom edge of the border and baste (tack) it in place. Pin the border on the front of the dress and machine stitch along the lace and the top edge of the border.

7 Pin the two back facings to the front facing along the side edges and machine stitch, taking a ½-in. (1-cm) seam allowance.

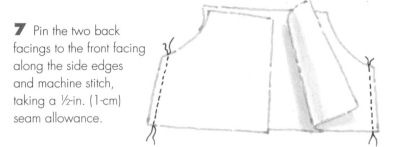

5 With right sides together, pin the two back pieces together down the center. Machine stitch, taking a ½-in. (1-cm seam) and stopping 6 in. (15 cm) from the top edge. Machine stitch horizontally across the end of the seam several times to strengthen it. Press the seam open.

8 Place the back and front right sides together and pin. Machine stitch the side seams, taking a ½-in. (1-cm) seam allowance. Press the seams open.

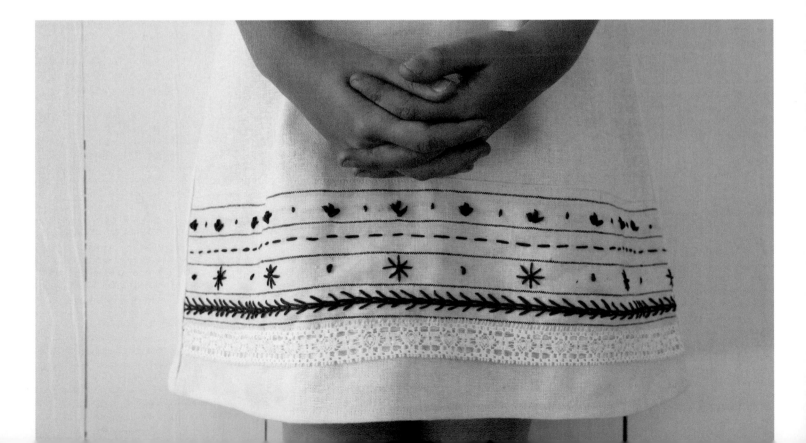

9 Turn under ½ in. (1 cm) all around the neckline, armholes, and unstitched back center edge of the dress and press. Do the same on the facings. Turn under a double ¼-in. (5-mm) hem around the bottom edge of the facing. Pin and machine stitch along the bottom edge of the facing.

10 To make the button loop, fold the small rectangle of linen in half widthwise and press. Open out, press the long edges in to meet the center crease mark, and re-fold along the center crease. Pin and machine stitch along the long, unfolded edge.

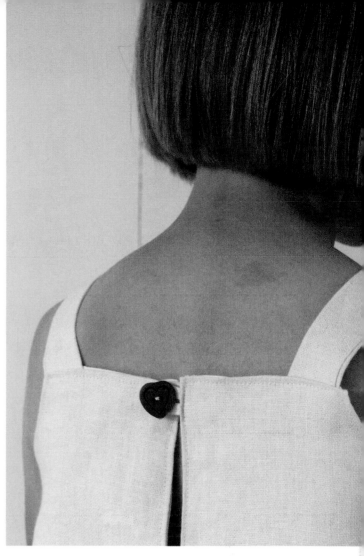

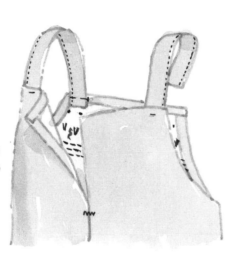

11 Pin the straps in place on the wrong side at the top of the dress, placing each end of each strap ¾ in. (2 cm) down from the top edge. With wrong sides together, aligning the pressed edges, pin the facing to the dress, sandwiching the ends of the straps in between. (Adjust the turned-under hem as you go if it does not match exactly.)

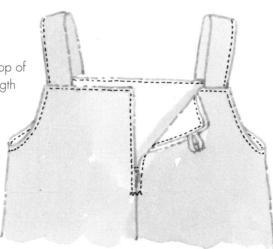

12 Place the button loop at the top of the back opening, adjusting the length as necessary to fit your button. Pin, baste (tack), and machine stitch all around the pressed-under armholes and neckline of the dress, stitching ⅛ in. (3 mm) from the edge and leaving the bottom edge of the facing loose.

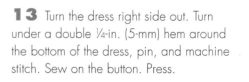

13 Turn the dress right side out. Turn under a double ¼-in. (5-mm) hem around the bottom of the dress, pin, and machine stitch. Sew on the button. Press.

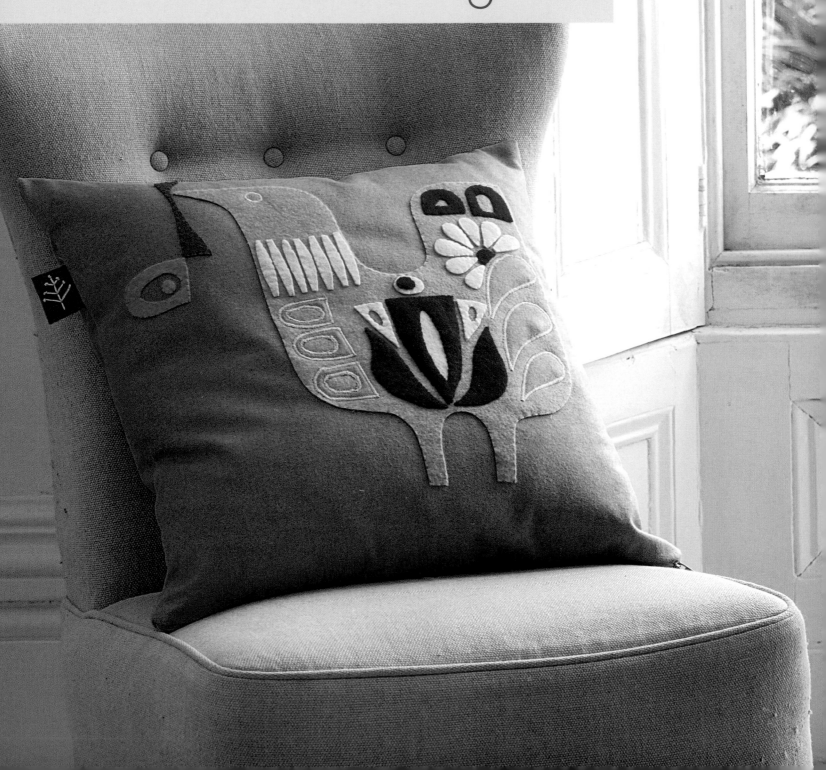

appliqué bird pillow

Pillows are a great way of changing the look of a room and of bringing color and pattern into neutral areas. In designing this pillow, I was influenced by the wonderfully organic, abstract designs on post-war Scandinavian textiles, ceramics, and glassware—but although it's retro in style, it would sit equally well on a Victorian bedroom chair or a 20th-century modern classic. I have used mostly felt for the appliqué, which does not have to be turned under around the edge as you stitch it in place. If you use a fabric that frays, either turn under the edges (remember to allow a little extra when you cut out the pieces) or machine a close zigzag stitch all around to attach the pieces.

materials

To fit a 20-in. (50-cm) pillow form (cushion pad):

Two 19-in. (48-cm) squares of yellow woollen fabric

Approx. 12 x 13 in. (30 x 33 cm) gray felt

Scraps of white, red, yellow, and green felt

14-in. (36-cm) zipper

20-in. (50-cm) pillow form (cushion pad)

1 Enlarge the templates on page 111 by 200 percent (see page 117). Trace them onto the felt (see page 118) and cut out.

2 Center the bird on the front panel. Pin, then slipstitch it in place (see page 120). Place all the remaining appliqué pieces in position. Pin and baste (tack) them in place (see page 118).

3 Slipstitch all the appliqué pieces in place (see page 120). If you are using a fabric that frays, turn under a small hem as you appliqué or machine stitch a line of close zigzag stitches all around the shapes to cover any raw edges.

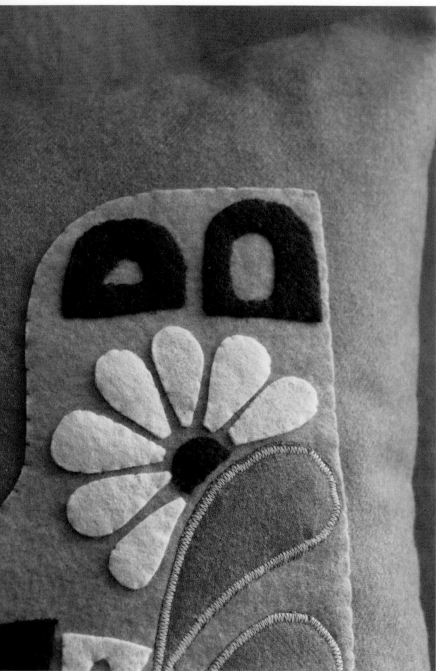

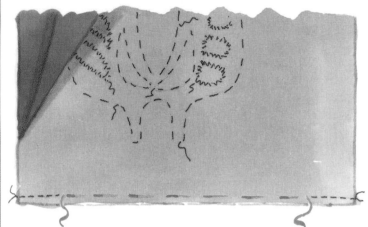

4 With right sides together, pin the front and back of the pillow (cushion) together along the bottom edge. Machine stitch for a distance of 2¼ in. (6 cm) from each end, taking a ½-in. (1-cm) seam allowance and leaving a gap the length of the zipper in the center. Baste (tack) the seam in between the two stitched ends.

5 Open the seam out and press flat. On the wrong side, position the closed zipper centrally on the pressed seam, zipper side down. Pin in place.

6 Using a zipper foot, stitch the zipper in place all the way around.

7 Remove the basting (tacking) stitches, turn over, and press flat.

8 Following the instructions for the tote bag (see page 13), make the label.

9 Open the zipper. With right sides together, pin the front and back panels together, inserting the label into the left seam, pointing inward. Machine stitch, taking a ½-in. (1-cm) seam allowance. Trim the corners and the seam allowance to ¼ in. (5 mm). Turn right side out, easing the corners into shape. Press. Insert the pillow form (cushion pad) to finish.

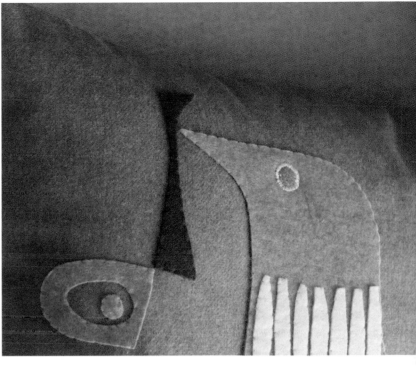

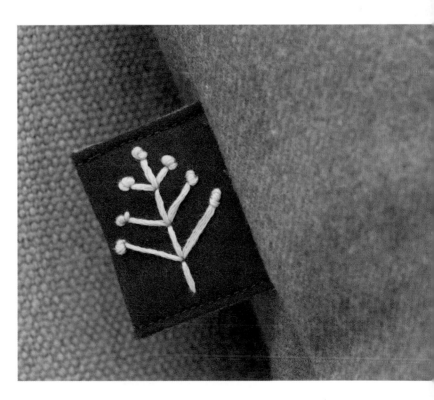

blue border throw

The soft blue used in the border of this cozy throw is typically Scandinavian. The design is worked in French knots, an easy stitch to do, which gives the throw a wonderful textural feel.

materials

Template and stitch guide on page 113

Tracing paper

Air-erasable marker pen

40 x 54 in. (100 x 138 cm) white fleece fabric

Two 40 x 13¼-in. (100 x 33 cm) pieces of blue woollen fabric for the border

1 ball of knitting cotton to match border color

1 Enlarge the template on page 113 by 200 percent (see page 117). Transfer the motif to the bottom half of one border strip and the top half of the other, placing it ¾ in. (2 cm) from the top edge and ½ in. (1 cm) in from the side (see page 118) and moving it along the border strips to repeat, as necessary.

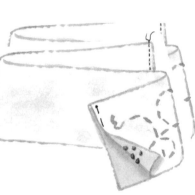

2 Using cotton yarn to match the border fabric, embroider the design in French knots (see page 123).

3 With right sides together, fold the borders in half widthwise. Pin and machine stitch down each short side.

4 Fold under a small hem along each side edge of the main section of the throw. Pin and machine stitch.

5 Turn the borders right side out. Turn under a hem on the front and back edge of the borders and pin to the main part of the throw, sandwiching the throw between the border edges. Pin in place, making sure that the pin catches the back part of the border. Baste (tack) and machine stitch. Press.

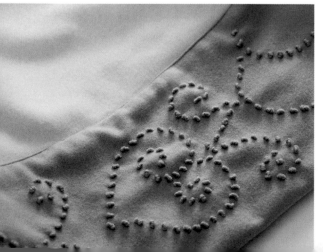

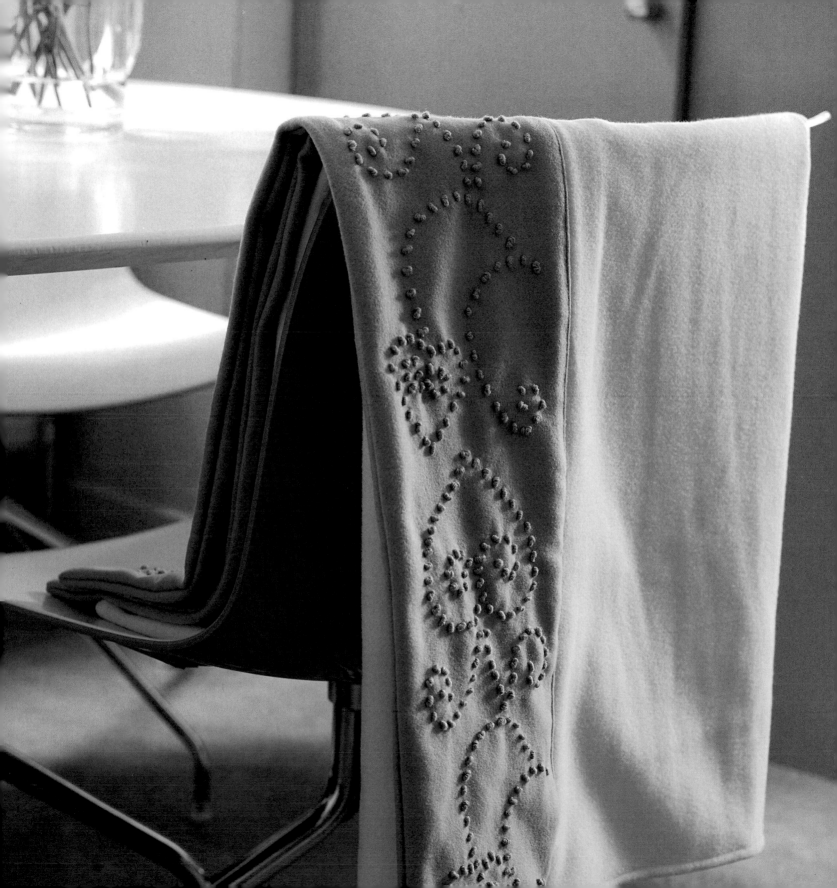

embroidered pelmet and curtain

I based this simple curtain and pelmet on traditional Scandinavian embroidery—but although the motifs are from another era, they sit very happily in a contemporary interior and would look charming in a white and wood kitchen.

To hang the pelmet, tap in small tacks through the tape along the top of the window frame. If your window is not suitable for a pelmet, embroider the floral design across the top of the curtain instead.

1 For both the curtain and the pelmet, cut one oblong of linen and one oblong of cotton lining fabric to the required size (see Box, opposite).

2 Using the tracing method (see page 118), transfer the embroidery motifs onto the pelmet and curtain linen. Following the stitch guides on page 112, embroider the motifs.

3 Place the back and front of the pelmet right sides together. Cut pieces of tape into 1½-in. (4-cm) lengths. Fold them in half lengthwise. Aligning the raw tape edges with the raw edges of the pelmet, sandwich the tape along the top of the pelmet between the two panels, spacing them evenly.

4 Taking a ½-in. (1-cm) seam allowance, machine stitch around all four sides, leaving a 5-in. (12-cm) gap in one side. Trim the seam allowances and cut across each corner to reduce the bulk. Turn the pelmet right side out and slipstitch the gap closed. Press.

5 Repeat Steps 3 and 4 to make the curtain—but instead of inserting tape, make pairs of ties following the instructions for the patchwork duvet cover on page 89 and insert them evenly along the top edge.

materials

White linen

White cotton fabric for lining

Red stranded embroidery floss (cotton)

White cotton webbing tape, ¾ in. (2 cm) wide

Working out fabric amounts
First, decide whether you want a very full curtain or one that hangs straight, as here. If you want the curtain to hang straight, just measure the width of the window and add about 4 in. (10 cm) extra.
For a full curtain, the fabric should be 2½ times the width of the space.
To work out the length of the curtain, measure where you want to stop and start the curtain and add ½ in. (1 cm) top and bottom for seam allowances.
For the pelmet, measure the width of the window frame and add ½ in. (1 cm) to each side. The depth should be 10½ in. (27 cm), which allows ½ in. (1 cm) top and bottom for the seam.

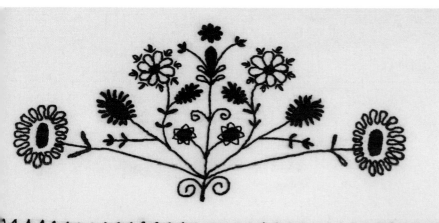

curtain tie-back

In rural households in the 18th century, sewing was an occupation for the winter months when the days were short and the nights were long. Scenes from everyday life were represented with stylized figures, such as the farming couple of this curtain tie-back, flowers, and animals. Crested cockerels, another motif used here, were popular motifs in Finnish embroidery and came from Norse mythology, when a cockerel was supposed to have perched on Yggdrasil—the giant ash tree that supports the nine worlds—to warn the gods of the approach of giants.

materials

Template and stitch guide on page 113

For each tie-back:

Approx. 13½ x 14 in. (34 x 35 cm) blue-and-white gingham fabric

Iron-on interfacing (optional)

Dressmaker's carbon paper

Approx. 25 in. (64 cm) ribbon, ½ in. (12mm) wide

Dark blue and white stranded embroidery floss (cotton)

Dark blue knitting yarn for tassels and cord

1 Enlarge the template on page 113 by 200 percent (see page 117), transfer it to the gingham fabric (see page 118), and cut out the front and back panel of the tie-back. If you wish, apply iron-on interfacing to firm up the front panel.

2 Using dressmaker's carbon paper, transfer the embroidery motif onto the front panel (see page 118), and embroider the design using blue and white stranded embroidery flosses (cottons).

3 Make a cord for the tassel (see page 124). To make the tassel, cut 26 strands of knitting yarn about 5½ in. (14 cm) in length. Fold them in half over the cord. Wind yarn around the tassel about ½ in. (1 cm) from the top, and tie in a knot. Repeat to make a second tassel.

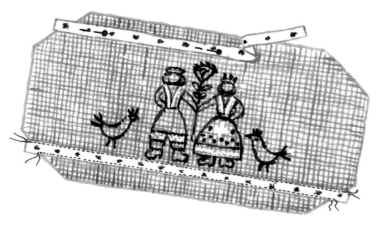

4 Pin the ribbon along the top and bottom edges of the panel, about ¾ in. (2 cm) from the edge. Machine stitch in place.

5 With right sides together, pin the front panel to the back panel. Sandwich the ends of the tassel cords in between the front and back panels, positioning them centrally on each side edge with the tassels facing in toward the center. Taking a ½-in. (1-cm) seam allowance, machine stitch all around, leaving a 4-in. (10-cm) gap in one side. Trim the seam allowance (see page 119). Turn the tie-back right side out. Slipstitch the gap closed (see page 120). Press.

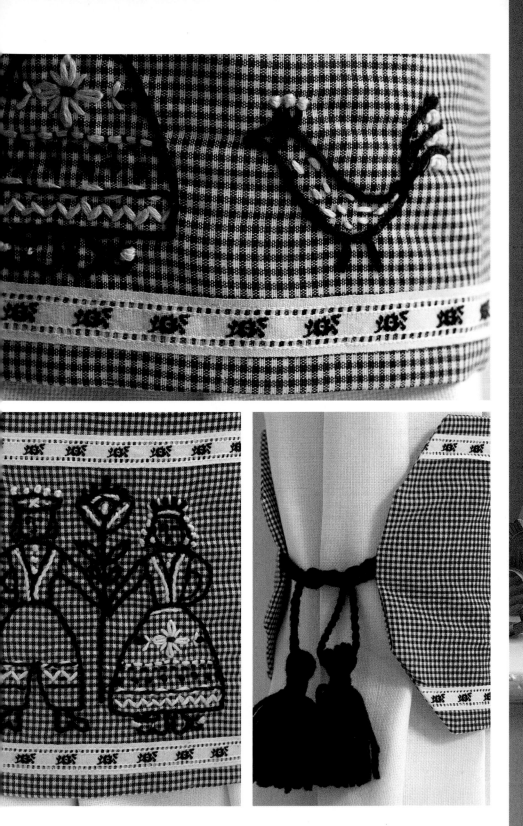
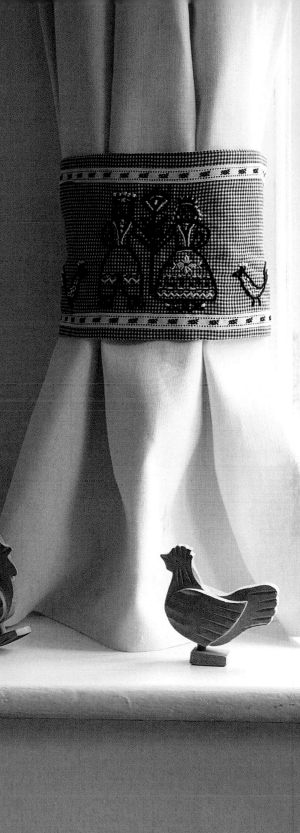

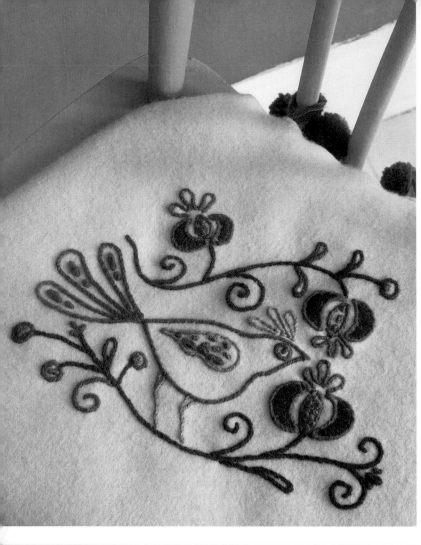

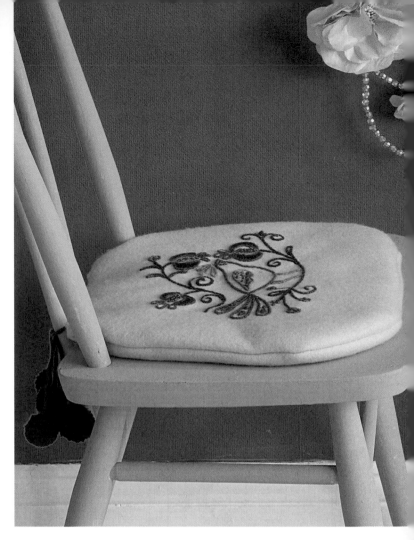

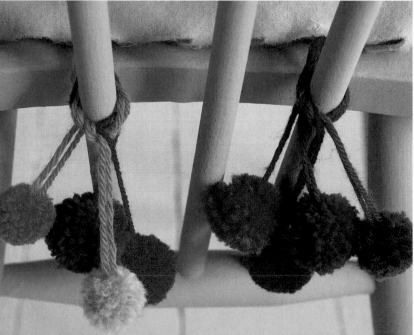

crested bird chair pad

The inspiration for this chair pad came from 18th-century Danish embroidery. The crested bird, a popular theme, is framed by pretty flowers, leaves, and tendrils. I have used a palette of bright, zingy colors against a cool, blue-gray background to bring it into the 21st century and have added colorful pompom ties.

materials

Template and stitch guide on page 114

Approx. 15 x 30 in. (38 x 76 cm) blue-gray felt

Dressmaker's carbon paper

Brightly colored knitting or tapestry yarn

Tapestry needle

7 small buttons

14-in. (36-cm) square of thin foam or batting (wadding), ½ in. (1.5 cm) thick

1 Enlarge the template on page 114 by 200 percent, transfer it onto the felt, and cut out one front and one back section. Using a craft knife or scissors, cut a small slit in each button tab to match the size of the buttons you are using.

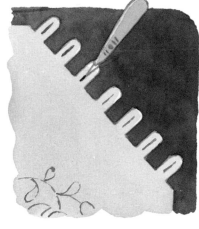

2 Using dressmaker's carbon paper, transfer the embroidery motif onto the front of the chair pad (see page 118). Following the stitch guide on page 114, embroider the bird and flower motifs in a selection of bright colors.

4 Make eight pompoms about 1½ in. (3–4 cm) in diameter, in different colors (see page 124).

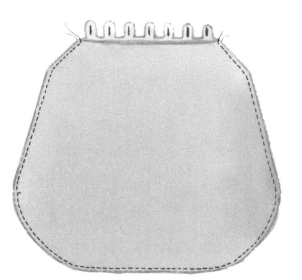

5 Gather the ties of four pompoms together and cut them to about 4½ in. (11 cm) in length. Pin them inside the cover at the button edge, toward the left-hand side; then repeat on the right-hand side. (The exact position of the pompom bunches will vary depending on what type of chair you have.) Machine a few stitches back and forth across the strands of wool that have been tucked into the wrong side of the cover. Insert foam or batting (wadding) into the cover to complete the pad.

3 Pin the front and back sections of the cover right sides together. Taking a ¼-in. (5-mm) seam allowance, machine stitch around three sides, leaving the button end open. Turn the cover right side out and press. Sew the buttons in position on the back of the cover.

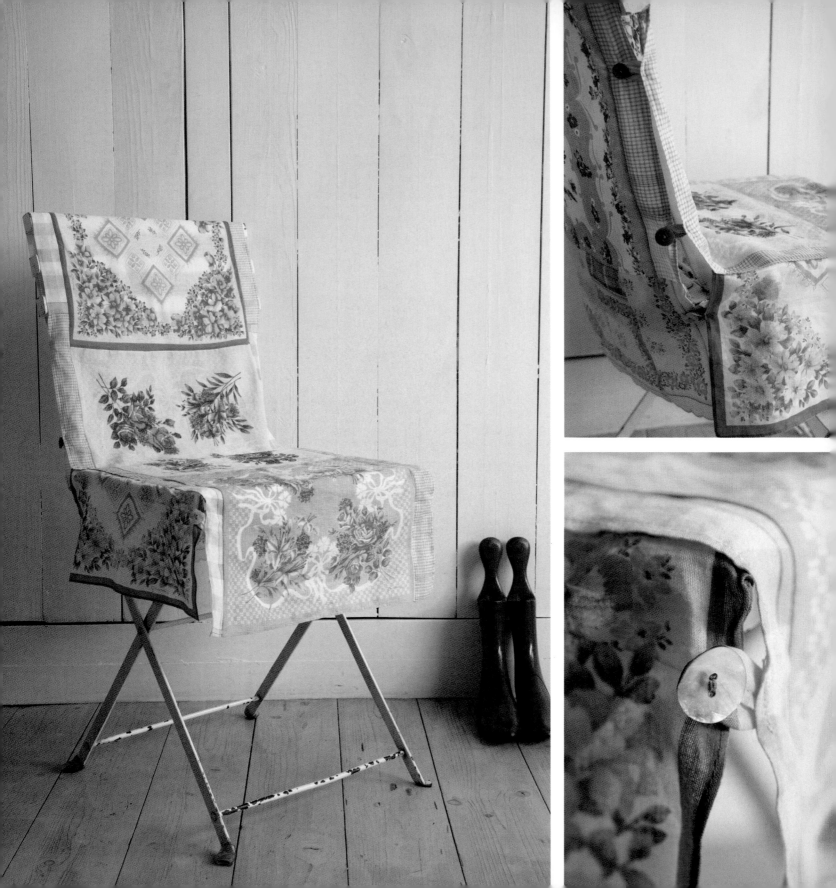

vintage floral slipcover

Making a slipcover is a good way to give an old chair a new lease on life. Look out for old linen tea towels or embroidered tray cloths and napkins in thrift stores and flea markets. The simple charm of pretty, faded, floral accessories and fabrics is typically Scandinavian. This slipcover is made from vintage handkerchiefs and will add a country element to any interior.

materials

Selection of patterned handkerchiefs

16–20 in. (40–50 cm) ribbon, ½ in. (1 cm) wide

8–10 buttons

1 First, measure your chair. The cover consists of one long piece that covers the legs, seat, and back, and two side pieces. Start with the long piece. Work out how far down the front legs you want the cover to extend, then measure up from that point, across the seat, up the back, and down the other side to the same level as on the front. Then work out the depth of the two side panels to match.

2 Lay the handkerchiefs on the floor and move them around until you're happy with the layout. You may need to cut them to get the right width and length—or simply to break the patchwork up into less regular shapes.

3 Make the long piece first. The panel should be larger then you need, so that you can trim and hem it to the right size. Pin the fabrics right sides together and machine stitch, taking ¼-in. (5-mm) seam allowances. Press the seams open. Trim the panel to size, leaving a ½-in. (1-cm) seam allowance all the way around. Turn over a double ¼-in. (5-mm) hem all around, pin, and machine stitch.

4 Make the two side panels in the same way, again leaving a ½-in. (1-cm) seam allowance all the way around. If necessary, turn over a double ¼-in. (5-mm) hem around one long and both short sides of each side panel, pin, and machine stitch. (If you use handkerchiefs, as I did, the sides will already be hemmed.) Pin the fourth side under the main panel, and machine stitch it in place, taking a ½-in. (1-cm) seam allowance.

5 Fold the ribbon in half widthwise, press, and machine stitch along the raw, unfolded edge. Cut into 2-in. (5-cm) sections. and fold each one in half to make a loop. Pin the loops in position on the wrong side of the panels; you will need at least two on each side of the back section and one on each leg section. Sew a line of stitching across the bottom raw edges of the loop to secure. Sew buttons in position to complete. Press.

cotton waffle bath mat

I look at all sorts of Scandinavian design when researching projects, from textiles to furniture and ceramics. The motif on this bath mat is based on designs painted on carved wooden chests over 200 years ago. Embroidered in blue on white cotton waffle, the design takes on a fresh and modern appeal. I always try to recycle as much as I can; here, I used part of an old cotton waffle towel for the front and toweling fabric for the backing.

materials

Dressmaker's carbon paper

Template and stitch guide on page 115

22 x 20 in. (56 x 50 cm) white cotton waffle

22 x 20 in. (56 x 50 cm) blue toweling

One ball thick blue-gray cotton yarn

Sharp-pointed tapestry needle

1 Enlarge the template on page 115 by 200 percent (see page 117). Using dressmaker's carbon paper (see page 118), draw the motif on the cotton waffle, centering it within the rectangle.

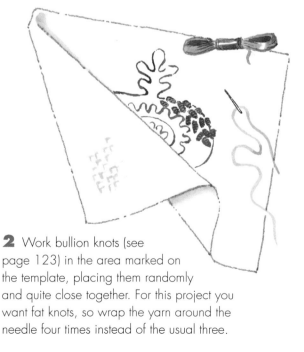

2 Work bullion knots (see page 123) in the area marked on the template, placing them randomly and quite close together. For this project you want fat knots, so wrap the yarn around the needle four times instead of the usual three.

3 Work the areas marked on the template in backstitch (see page XX).

4 With right sides together, pin the front and back together, and machine stitch around all four sides ½ in. (1cm) from the edge, leaving a 4–5-in. (10–12-cm) gap in one side. Clip the corners and turn the mat right side out. Ease the corners into shape.

5 Fold in the raw edges of the gap, pin in place, and slipstitch the gap closed (see page 120). Press to finish.

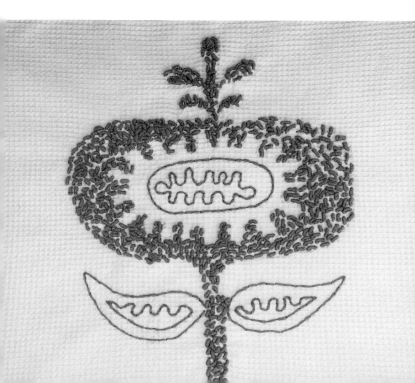

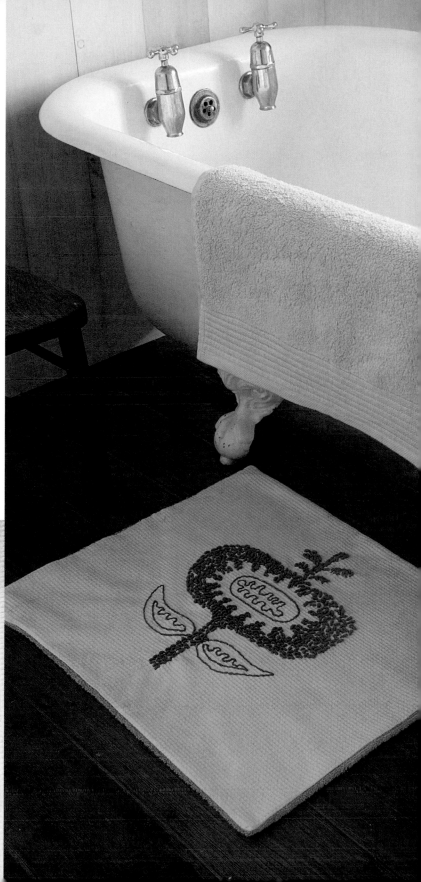

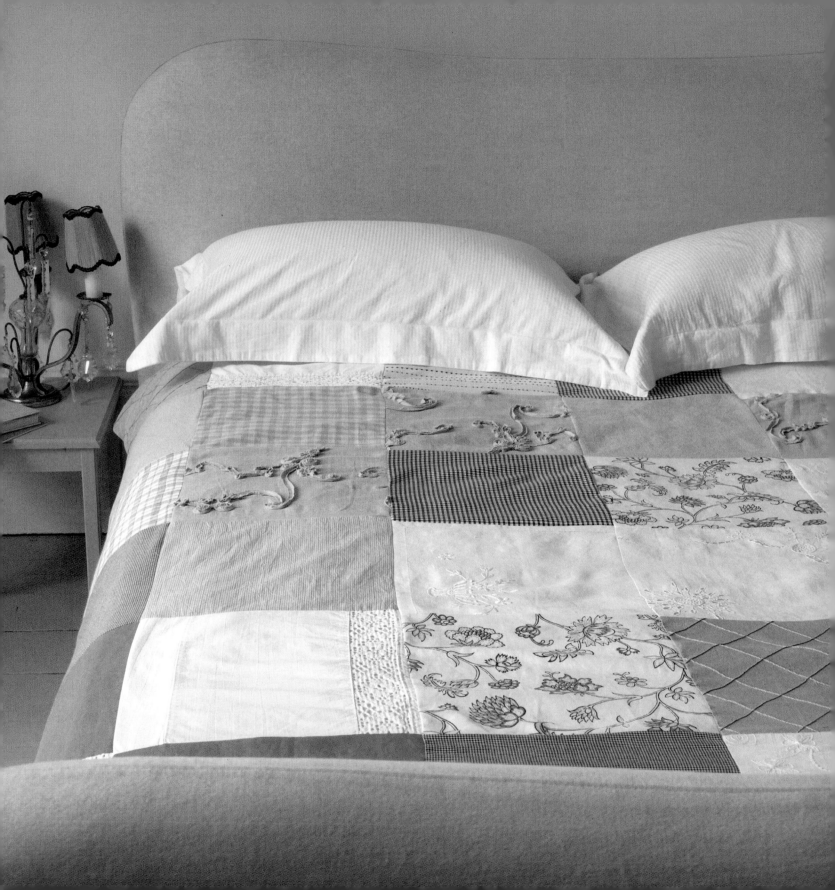

patchwork duvet cover

In many cultures, patchwork has been a means of making something decorative and useful out of leftover scraps of fabric. All available pieces were used, from clothes that the children had grown out of to scraps left over from dressmaking or pieces cut from a worn tablecloth. The patchwork I have made is no different, transforming recycled scraps into something that is very special.

Scandinavian interiors are often decorated in chalky hues of white, blues, and grays, to reflect as much light as possible. Here, different textures and patterns are held together by that same palette of cool, soft colors. I have also included scraps of vintage embroidered linens for a look that is pretty and sophisticatedly Scandinavian.

materials

Makes a quilt measuring approx. 74½ in. (186 cm) square

Selection of scrap fabrics

Old flat sheet for backing

12 pieces of fabric measuring 20 x 1½ in. (50 x 4 cm) for ties

1 Cut out 49 pieces of fabric measuring 11½ in. (29 cm) square. Lay them out on the floor in seven rows of seven squares each, moving them around until you have a pleasing combination of colors and prints.

2 Working one row at a time, pin the squares right sides together and machine stitch, taking a ½ in. (1-cm) seam. Press all the seams to one side, alternating the direction in each row.

3 With right sides together, aligning the seams, pin the seven rows together. Machine stitch, again taking a ½-in. (1-cm) seam allowance. Press the seams to one side.

4 To make the ties, fold the rectangles of fabric in half widthwise, wrong sides together, and press. Open out, then press under ½ in. (1 cm) along each long edge. Fold in the raw edges at each short end of the strip and press, then re-fold along the center crease. Pin, then machine stitch along the three unfolded sides, ⅛ in. (3 mm) from the edge.

5 Turn under a double ½-in. (1-cm) hem along one edge of the patchwork. Pin and machine stitch.

6 Lay the patchwork square down on an old double sheet, right sides together, making sure that the hemmed edge is flush with the top edge of the sheet. Pin, then baste (tack) the patchwork to the sheet along the side edges and the un-hemmed end, making sure that the layers are smooth and wrinkle free. Trim off any excess sheet and machine stitch around the three unhemmed sides, ½ in. (1 cm) from the edge.

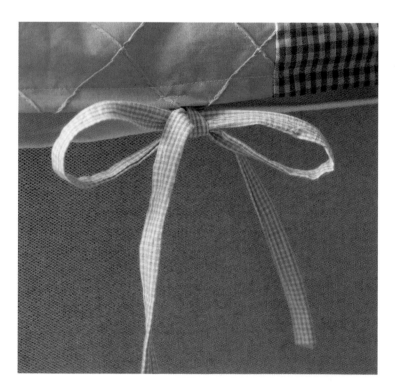

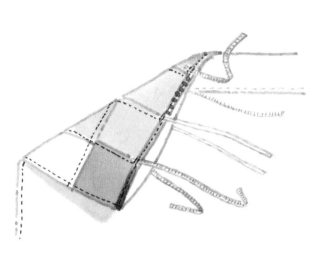

7 Pin the pairs of ties to the inside of the front and back sections of the duvet cover, spacing them evenly along the open end. Sew across each tie end, going back and forth two or three times to secure. Turn the cover right side out and press.

cross-stitch heart pillowslip

The heart motif has been used in Scandinavian design for many centuries and red on white is very traditional. Cross stitch works well on cotton waffle, as you can follow the squares to keep the stitching even. This pillowslip would look charming on a child's bed with a red gingham quilt.

materials

Template on page 112

31½ x 20½ in. (80 x 52 cm) white cotton waffle fabric

34½ x 20½ in. (88 x 52 cm) white cotton fabric

Red stranded embroidery floss (cotton)

1 On the cotton waffle piece, turn under ½ in. (1 cm), and then 2½ in. (6 cm) along one short end. Pin and machine stitch.

2 On the plain cotton piece, turn under a ½-in. (1-cm) double hem, on one short end. Pin and machine stitch.

3 Enlarge the template on page 112 by 200 percent and transfer it to the center of the cotton waffle panel. Using red stranded embroidery floss (cotton), embroider the heart motifs in cross stitch (see page 122).

4 With right sides together, pin the back and front panels together, aligning the raw edges along the bottom and two long sides. Fold back the hemmed end of the plain cotton so that it is the same length as the cotton waffle side. Machine stitch along the side and bottom edges. Zigzag stitch the raw edges. Turn the pillowslip right side out and press.

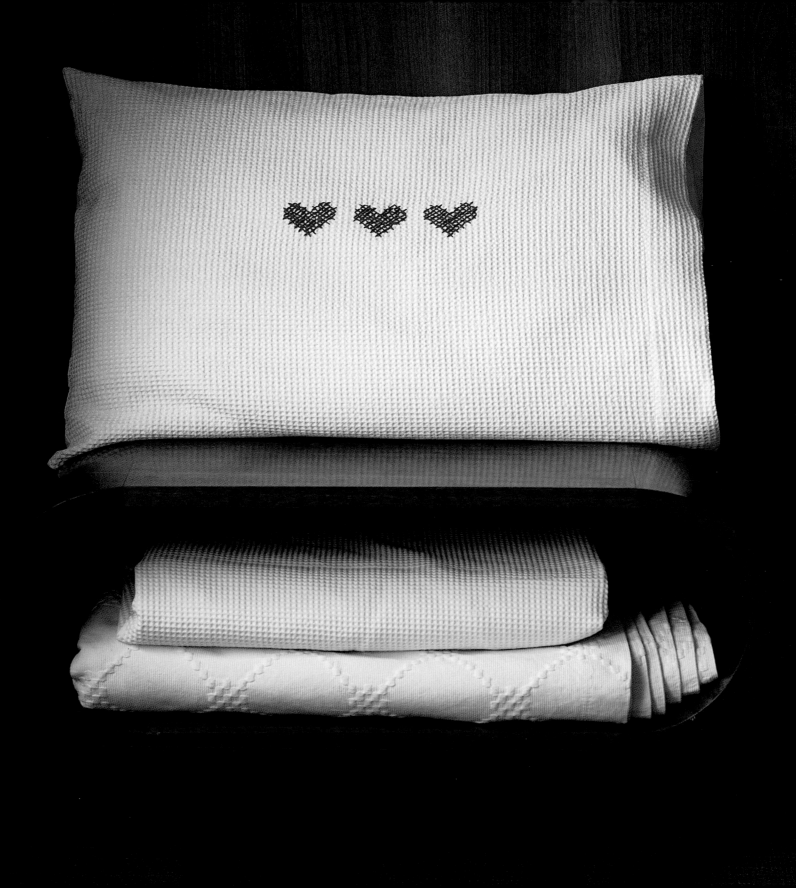

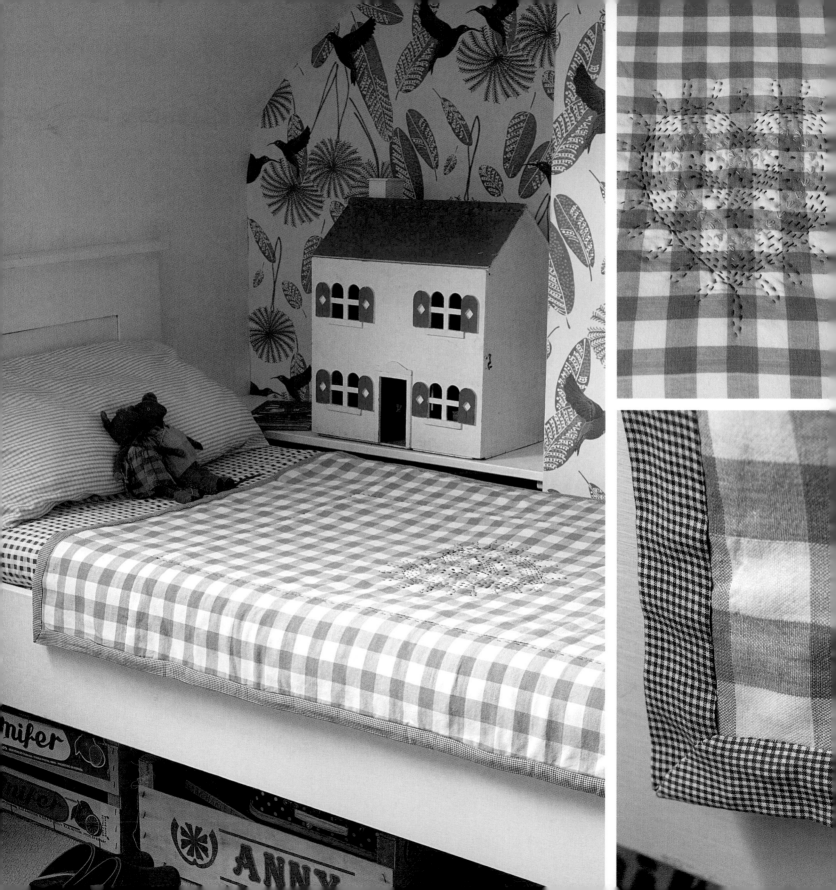

gingham heart quilt

Gingham is a favored fabric in Scandinavia. It looks fresh and clean, and you can combine it quite happily with florals and ticking. For this quilt I chose a large-squared gingham and embroidered the traditional heart motif in the center in a simple running stitch.

1 Lay one piece of gingham right side down on the floor, with the batting (wadding) on top. Place the second gingham piece on top, right side up, aligning the edges. Pin and then baste (tack) the three layers together. Machine stitch the layers together, working from the center out to the four corners, and then to the middle of each side, and finally around the outside edge.

2 Using dressmaker's carbon paper, transfer the heart design to the center of the quilt (see page 118). Following the stitch guide on page 116, embroider the motif, stitching through all three layers.

3 Machine stitch across the short ends of quilt 8¼ in. (21 cm) from the edge, then machine stitch along each long edge 7 in. (18 cm) from the edge to form a central oblong. Hand stitch a row of running stitch ¼ in. (5 mm) all around the central oblong, ¼ in. (5 mm) outside the machine stitching.

materials

Template and stitch guide on page 116

Dressmaker's carbon paper

Two 35½ x 53½-in. (90 x 136-cm) pieces of large-checked green gingham fabric

35½ x 53½ in. (90 x 136 cm) thin batting (wadding)

Two 55½ x 2¾-in. (141 x 7-cm) and two 37½ x 2¾-in. (95 x 7-cm) strips of small-checked blue gingham for borders

Dark blue, mid-green, pale gray-blue, and pale blue stranded embroidery floss (cotton)

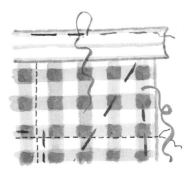

4 Press each of the four border strips in half widthwise, then press under ½ in. (1 cm) to the wrong side along each long raw edge. Open out the strips. With right sides together, aligning the raw edges, pin and baste (tack) the first strip along one edge of the quilt, leaving an overlap of 1 in. (2.5 cm) at each end. Machine stitch along the first crease through all three layers, leaving the overlap at each end unstitched. Repeat with the other three strips. Press. Remove the basting (tacking) stitches.

5 Miter the corners on the front of the quilt (see page 120), slipstitching the joins as far as the central crease in the border strip. Trim the seam allowances to ¼ in. (5 mm). Fold the border strips to the back of the quilt, and miter the corners. Pin and then slipstitch the turned-under edge to the quilt.

felt bag with embroidered bird page 6

BASE
cut 1

enlarge by 250 percent

BACK/FRONT
cut 1 of each

- french knot
- backstitch
- straight stitch
- whipped backstitch
- bullion knot
- star stitch
- seed stitch

APPLIQUÉ MOTIFS
cut 1 of each

blue dandelion
felted bag *page 10*

enlarge by 200 percent

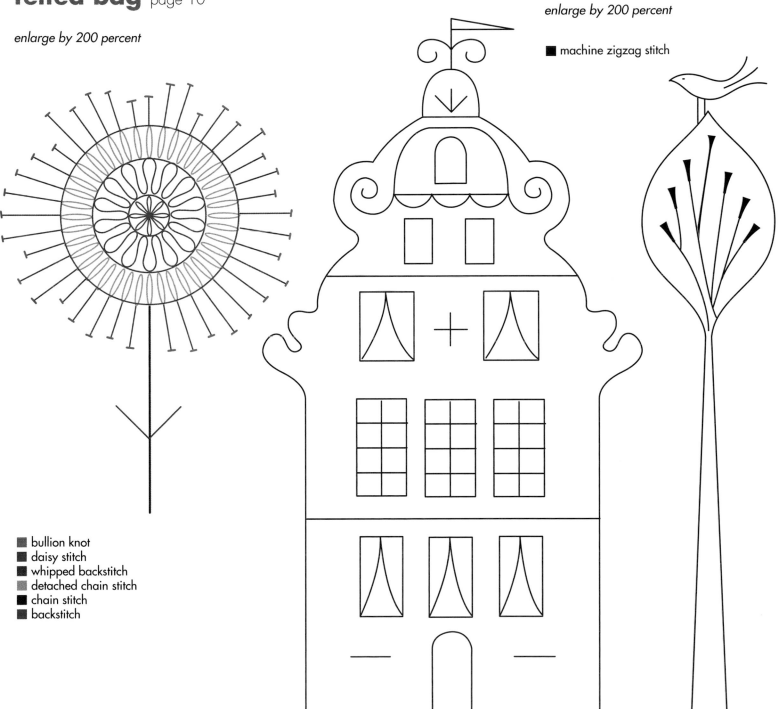

stortorget tote bag *page 12*

enlarge by 200 percent

■ machine zigzag stitch

■ bullion knot
■ daisy stitch
■ whipped backstitch
■ detached chain stitch
■ chain stitch
■ backstitch

log roll with twig detail
page 16

enlarge by 200 percent

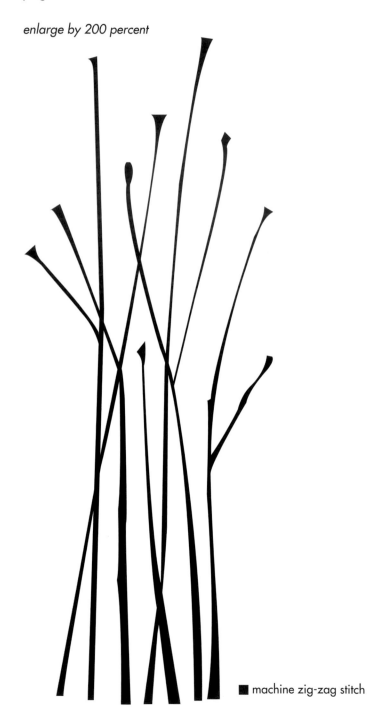

■ machine zig-zag stitch

floral cutwork bag page 20

enlarge by 242 percent

■ whipped backstitch
■ satin stitch
■ bullion knot
■ buttonhole stitch
■ daisy stitch

LABEL
cut 2

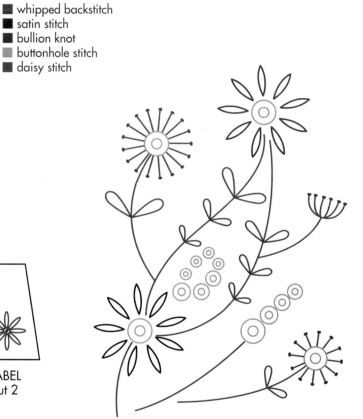

folk horse wall hanging page 24

enlarge by 336 percent

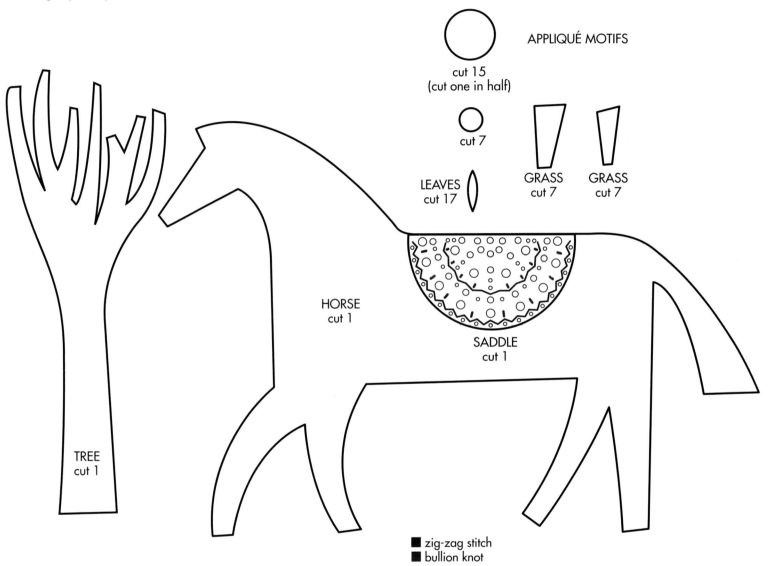

APPLIQUÉ MOTIFS

cut 15
(cut one in half)

cut 7

LEAVES
cut 17

GRASS
cut 7

GRASS
cut 7

HORSE
cut 1

SADDLE
cut 1

TREE
cut 1

■ zig-zag stitch
■ bullion knot

reindeer *page 28*

enlarge by 200 percent

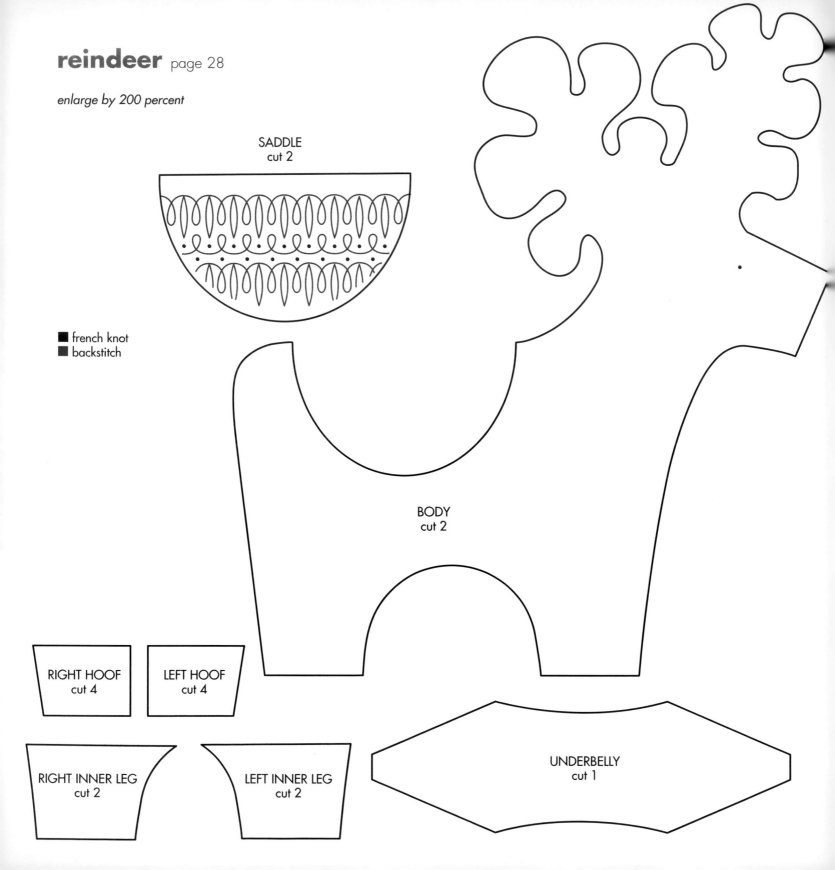

SADDLE
cut 2

■ french knot
■ backstitch

BODY
cut 2

RIGHT HOOF
cut 4

LEFT HOOF
cut 4

RIGHT INNER LEG
cut 2

LEFT INNER LEG
cut 2

UNDERBELLY
cut 1

coat hanger cover page 26

enlarge by 200 percent

■ cross stitch

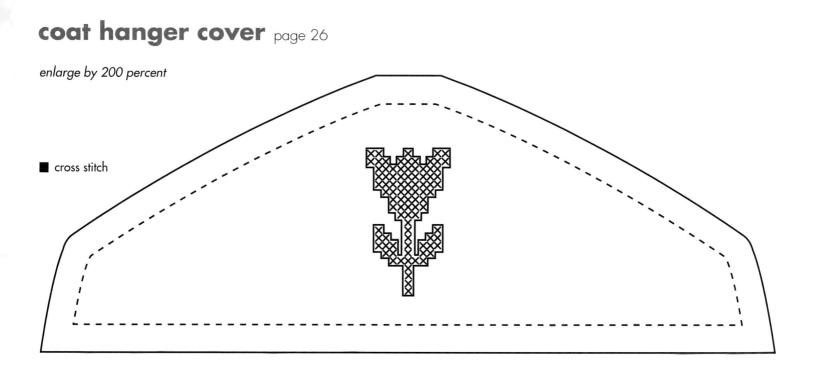

embroidered gift tags page 38

enlarge by 200 percent

■ french knot
■ backstitch
■ straight stitch
■ star stitch
■ seed stitch
■ cross stitch

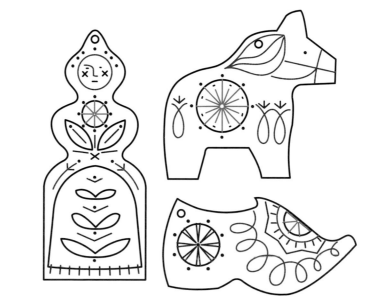

christmas stockings page 34

enlarge by 250 percent

- ■ french knot
- ■ straight stitch
- ▨ whipped backstitch
- ■ seed stitch
- ▨ bullion knot

- ■ french knot
- ▨ whipped backstitch
- ■ bullion knot
- ■ backstitch

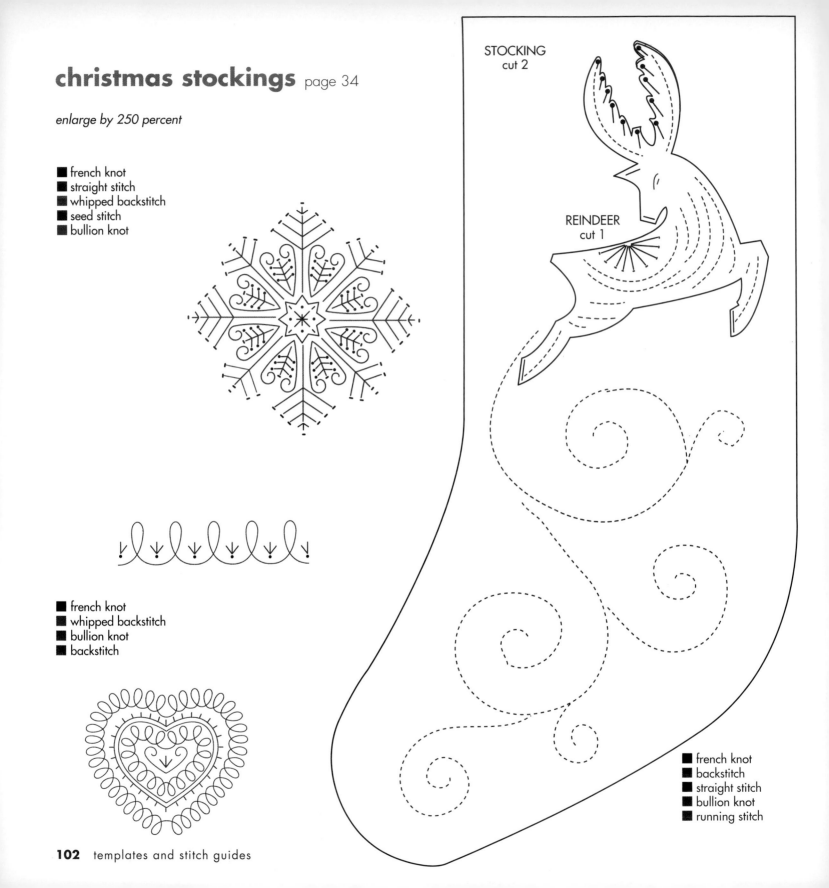

STOCKING
cut 2

REINDEER
cut 1

- ■ french knot
- ■ backstitch
- ■ straight stitch
- ■ bullion knot
- ■ running stitch

folk bird garland page 36

enlarge by 200 percent

- ■ french knot
- ■ backstitch
- ■ straight stitch
- ■ star stitch
- ■ daisy stitch

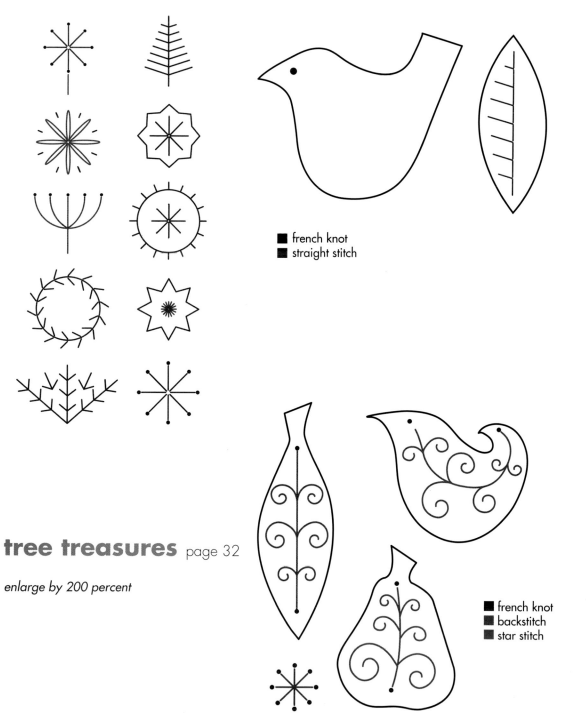

- ■ french knot
- ■ straight stitch

tree treasures page 32

enlarge by 200 percent

- ■ french knot
- ■ backstitch
- ■ star stitch

embroidered shelf edging

page 40

enlarge by 200 percent

- ■ daisy stitch
- ■ bullion knot
- ■ straight stitch

folk-heart egg cozies

page 50

enlarge by 200 percent

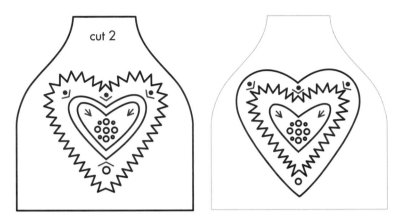

cut 2

- ■ french knot
- ■ straight stitch

button badges and cute clips page 58

enlarge by 200 percent

- ■ french knot
- ■ backstitch
- ■ straight stitch
- ■ chain and fly stitch
- ■ seed stitch
- ■ daisy stitch

apron page 42

enlarge by 200 percent

■ machine zig-zag stitch
■ french knot

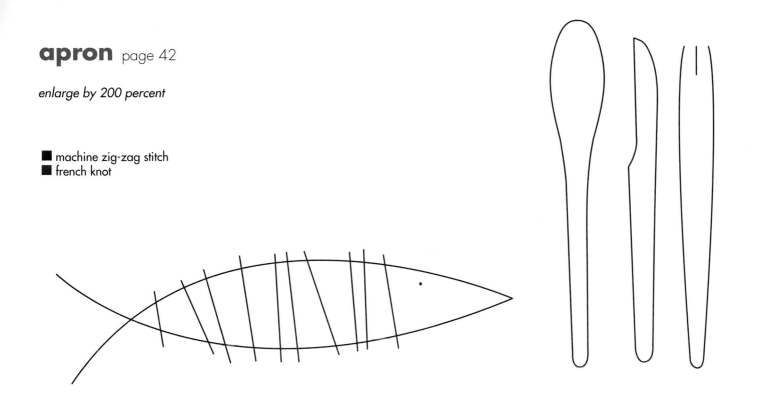

blue herring tea towel page 46

enlarge by 200 percent

■ machine zig-zag stitch

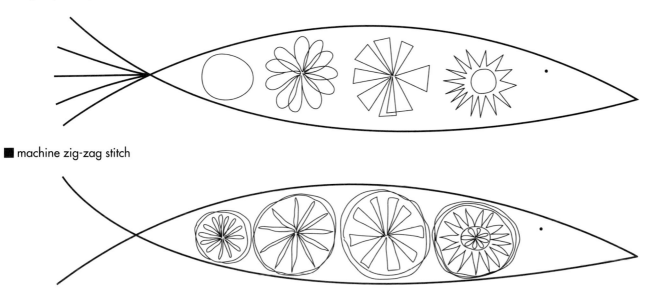

felt baby boots page 66

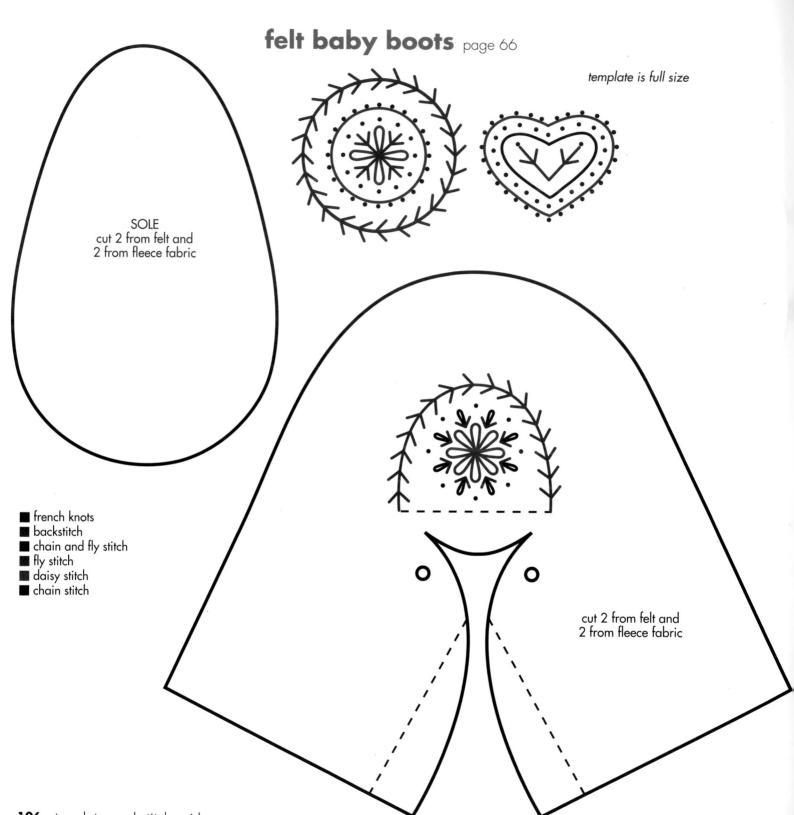

template is full size

SOLE
cut 2 from felt and
2 from fleece fabric

- ■ french knots
- ■ backstitch
- ■ chain and fly stitch
- ■ fly stitch
- ■ daisy stitch
- ■ chain stitch

cut 2 from felt and
2 from fleece fabric

felted wool slippers page 54

enlarge by 133 percent

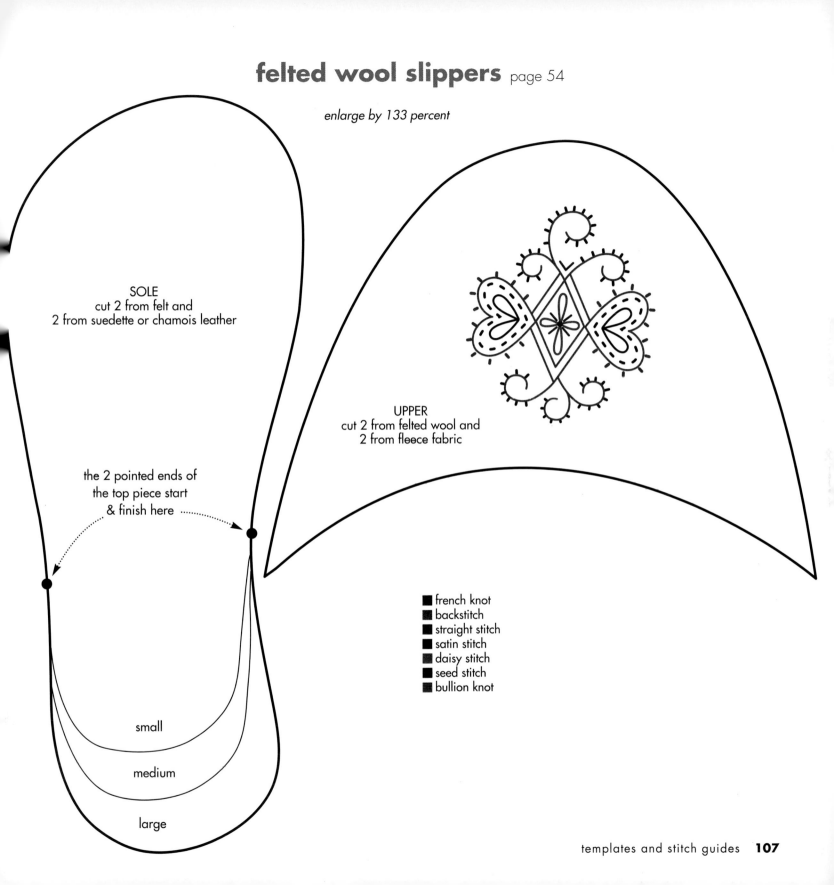

SOLE
cut 2 from felt and
2 from suedette or chamois leather

UPPER
cut 2 from felted wool and
2 from fleece fabric

the 2 pointed ends of
the top piece start
& finish here

small

medium

large

■ french knot
■ backstitch
■ straight stitch
■ satin stitch
■ daisy stitch
■ seed stitch
■ bullion knot

embroidered linen collar page 60

enlarge by 200 percent

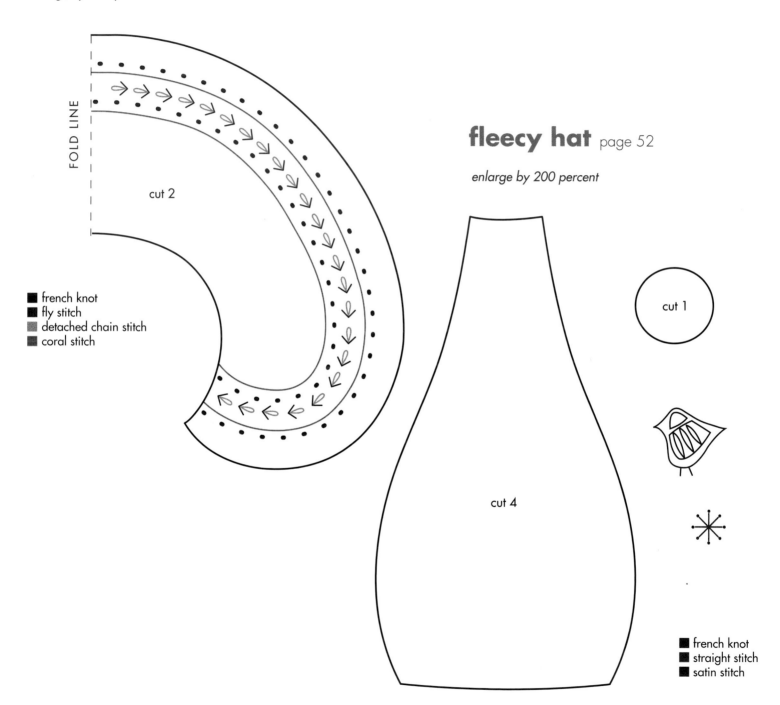

FOLD LINE

cut 2

- ■ french knot
- ■ fly stitch
- ▨ detached chain stitch
- ■ coral stitch

fleecy hat page 52

enlarge by 200 percent

cut 1

cut 4

- ■ french knot
- ■ straight stitch
- ■ satin stitch

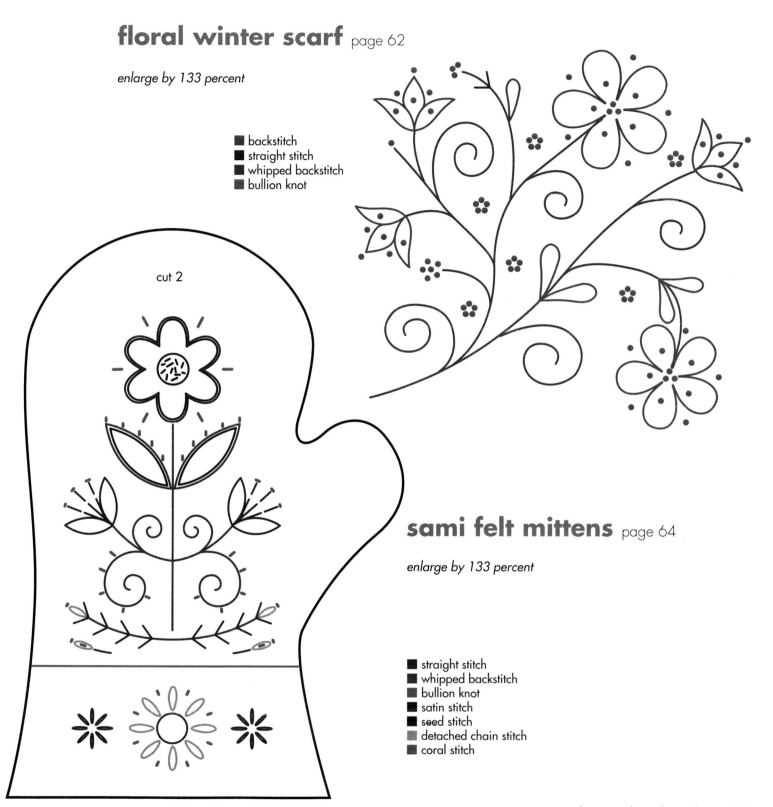

floral winter scarf page 62

enlarge by 133 percent

■ backstitch
■ straight stitch
■ whipped backstitch
■ bullion knot

cut 2

sami felt mittens page 64

enlarge by 133 percent

■ straight stitch
■ whipped backstitch
■ bullion knot
■ satin stitch
■ seed stitch
■ detached chain stitch
■ coral stitch

sampler linen dress page 68

enlarge by 400 percent

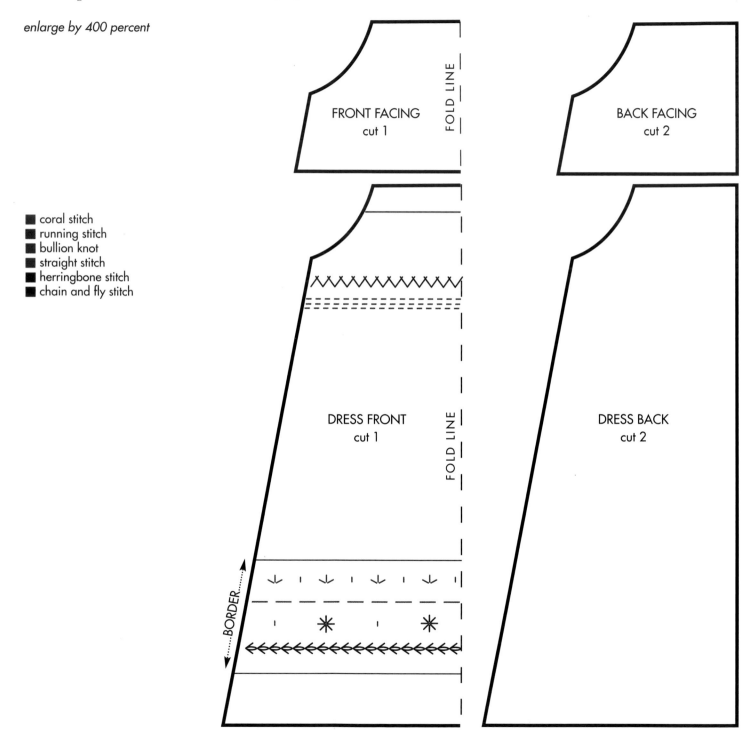

- ■ coral stitch
- ■ running stitch
- ■ bullion knot
- ■ straight stitch
- ■ herringbone stitch
- ■ chain and fly stitch

FRONT FACING
cut 1

BACK FACING
cut 2

FOLD LINE

DRESS FRONT
cut 1

DRESS BACK
cut 2

FOLD LINE

BORDER

appliqué bird pillow page 72

enlarge by 200 percent

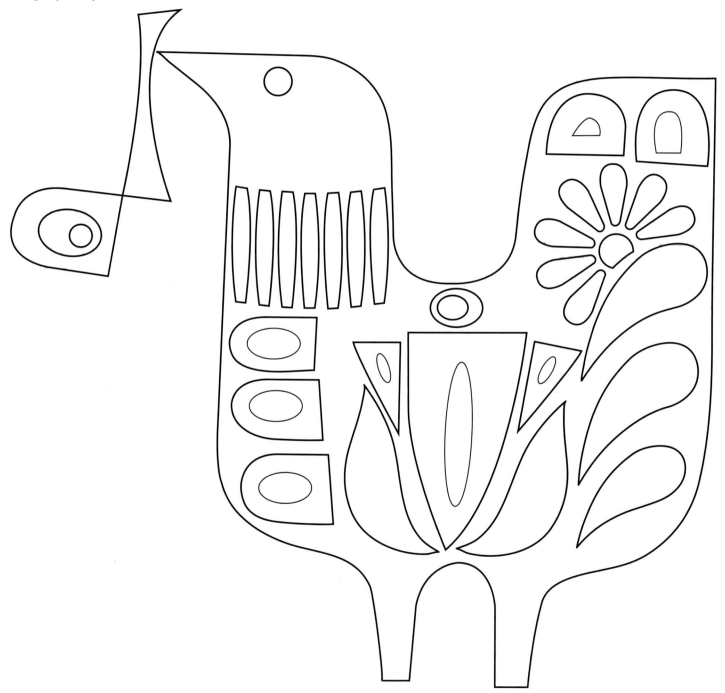

embroidered pelmet and curtain page 78

enlarge by 200 percent

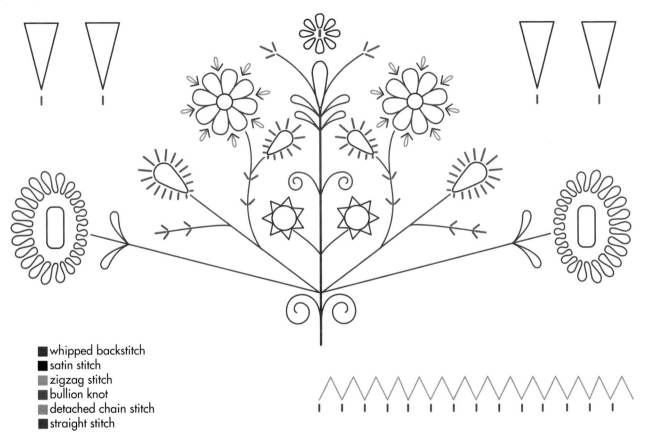

■ whipped backstitch
■ satin stitch
■ zigzag stitch
■ bullion knot
■ detached chain stitch
■ straight stitch

cross-stitch heart pillowslip page 92

enlarge by 200 percent

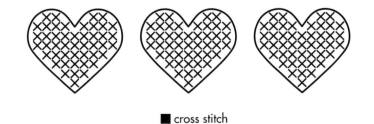

■ cross stitch

curtain tie-back page 80

enlarge by 200 percent

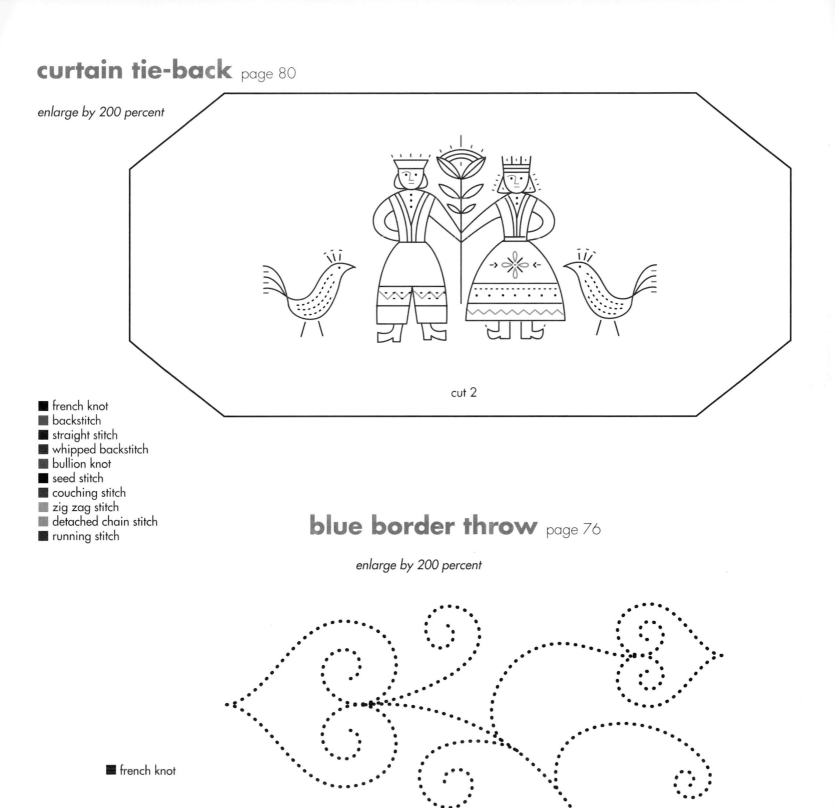

cut 2

- ■ french knot
- ■ backstitch
- ■ straight stitch
- ■ whipped backstitch
- ■ bullion knot
- ■ seed stitch
- ■ couching stitch
- ■ zig zag stitch
- ■ detached chain stitch
- ■ running stitch

blue border throw page 76

enlarge by 200 percent

- ■ french knot

crested bird chair pad page 82

enlarge by 200 percent

■ whipped backstitch
■ bullion knot
■ satin stitch

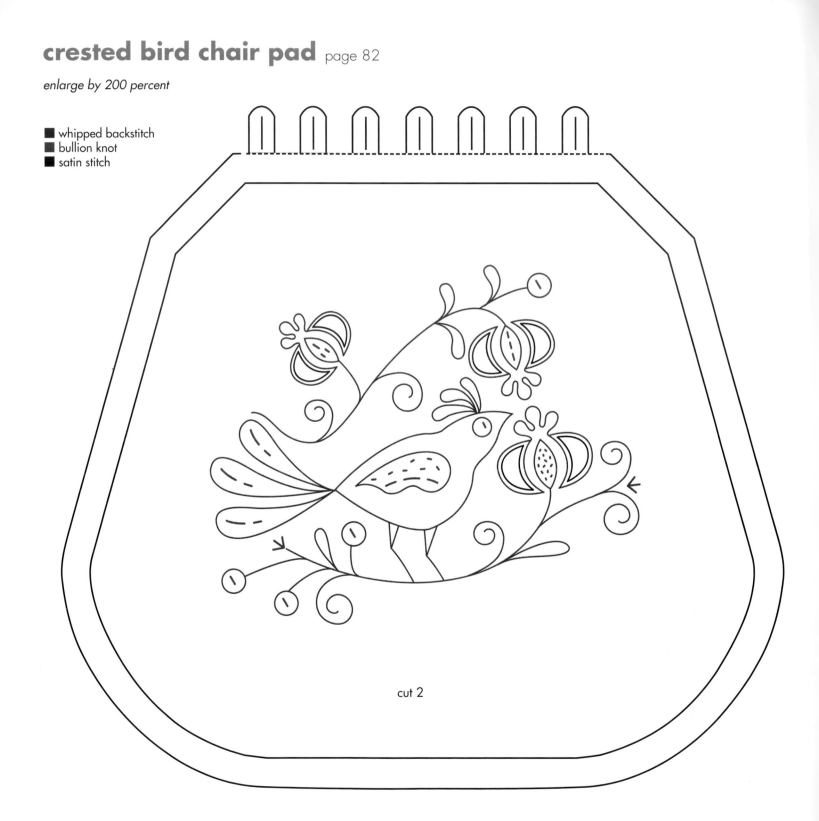

cut 2

cotton waffle bathmat page 86

enlarge by 200 percent

■ backstitch
■ fill in the area outlined in purple
 with bullion knots

gingham heart quilt page 94

enlarge by 200 percent

■ running stitch
■ bullion knot
■ detached chain stitch
■ fly stitch

techniques

tools and equipment

The projects in this book can all be made with very little equipment. A sewing machine is essential, but it can be a very simple model. Even the most basic of modern sewing machines offers a variety of stitches. For this book, you will only need straight stitch and zigzag. But the other stitches that I find very useful on a machine are an automatic one-step button hole, a zigzag overlock-type stitch to neaten raw edges on seams, and a stretch stitch. If you buy a machine with these stitches, then it will also have some decorative stitches such as scallops and hearts, which can be useful.

In addition, you'll need the following:
• Dressmaker's shears for cutting fabric. Never, ever use your dressmaking shears for cutting paper, as this will quickly blunt them.

• Small, sharp-pointed scissors for cutting threads, clipping seam allowances, and trimming.

• Paper scissors for cutting patterns and templates.

• A long ruler, a flexible measuring tape, and a pencil for measuring and marking fabric.

• Tracing paper and a fabric marker pen that either fades away after a couple of days or can be brushed off, and/or dressmaker's carbon paper for transferring motifs to fabric.

• Pins, hand-sewing needles (size 6–8 are a useful medium size), and embroidery needles. The type of embroidery needle depends on the fabric and thread you are using. Sharp-pointed needles called crewels are thin, but are designed to take thicker-than-normal thread and are ideal for most decorative embroidery on plain-weave fabrics. Chenilles are sharp-pointed and heavier, and take thicker threads for work on heavyweight fabrics.

• A steam iron and ironing board are essential for pressing seams.

fabrics and threads

I have used natural fabrics in all the projects, especially linen, cotton, and wool. I also used wool felt for many projects. This can be difficult to source, but you can substitute acrylic felt. Alternatively, try making your own from an old sweater. Make sure that it is 100 percent wool; it won't felt if it contains any man-made fibers. Put the wool items in the washing machine at the hottest setting; they will emerge shrunken, but with that lovely felted look. I sometimes do this twice for a really felted piece.

The other essential is sewing thread. Ideally, try to match the thread type to the fabric (synthetic thread for synthetic fabric, cotton thread for cotton fabric) and match the thread color as closely as possible to the fabric color.

For most of the embroidery projects in this book, I have used stranded embroidery floss (cotton). I usually use all six strands. If I have used less or more, this will be specified in the instructions. I have also used pearl cotton and embroidery yarn such as crewel, Persian, or tapestry yarn. However, much depends on the effect you want to create so feel free to experiment.

changing the size of motifs

The project instructions and the templates on pages 96–116 specify how much you need to enlarge motifs in order for your project to be the same size as the ones I made, but you may well wish to adapt a design to make something completely different—so it's worth knowing how to enlarge or reduce motifs to the size you require.

Enlarging motifs

First, decide how big you want the pattern or motif to be. Let's say that you want a particular shape to be 10 in. (25 cm) tall.

Then measure the template that you are working from—5 in. (12.5 cm) tall, for example.

Take the size that you want the pattern or motif to be (10 in./25 cm) and divide it by the actual size of the template (5 in./12.5 cm). Multiply that figure by 100 and you get 200—so you need to enlarge the motif on a photocopier to 200 percent.

If you want to make something that's too big to fit on a standard commercial photocopier, make "registration marks" (either circles or a dotted line) on the original pattern. Enlarge one half of the pattern and then the other, making sure that the registration marks appear on both photocopies, and then tape the two parts of the pattern together, aligning the registration marks.

Reducing motifs
If you want a motif on the finished piece to be smaller than the pattern, the process is exactly the same. For example, if the pattern is 5 in. (12.5 cm) tall and you want the motif to be 3 in. (7.5 cm) tall, divide 3 in./7.5 cm by the actual size of the template (5 in./12.5 cm) and multiply by 100, which gives you a figure of 60. So the figure that you need to key in on the photocopier is 60%.

transferring patterns and motifs
In most of the projects, you will have to transfer the embroidery pattern or motif onto the fabric. I use three different methods.

The first—and the easiest—is tracing. If the fabric is sheer enough, lay it over the pattern and trace it, using a dressmaker's fade-away marker pen. Alternatively, tape the pattern to a window with the fabric on top, and draw over the lines of the pattern.

The second method is for thick or dark fabrics. Lay dressmaker's carbon paper on the fabric, carbon side down. Lay the embroidery pattern on top and trace over the motif with a ballpoint pen. You can buy carbon paper in different colors suitable for different fabrics.

The final method is for the few fabrics that have a fluffy pile and are difficult to draw on. Trace the motif onto a piece of white tissue paper and pin it onto the fabric. Using cotton sewing thread and a closely spaced running stitch, baste (tack) through the tissue paper and fabric along the pattern lines. Remove the tissue paper, complete the embroidery, and then remove the basting (tacking) stitches.

machine stitching
The key to successful machine stitching is to stitch slowly and in a straight line. Learn to control the speed so that the machine doesn't run away with you!

Straight machine stitch is used for seams; set a stitch length of 10–12 on a scale of 1–20, and a stitch width of 0.

Topstitching is a straight stitch that is stitched from the right side of the fabric. Because it will be visible when the project is completed, it's important to stitch in a straight line. For the projects in this book, topstitching should be done about ⅛ in. (3 mm) from the edge.

Zigzag stitching is used for finishing seam allowances to stop them from fraying and to create a satin-stitch effect in machine embroidery. The stitch width varies depending on the fabric and the desired effect.

basting (tacking)
This is a temporary way of holding two or more pieces of fabric together before stitching, if pins would get in the way. It's useful when making seams in awkward corners, or when sewing curved edges together, or when another layer will be added on top and you wouldn't be able to get at the pins.

To baste (tack) by hand, sew long running stitches (see page 121) and don't secure the thread at the end; when you want to remove the basting (tacking), just snip off the knot at the start of the thread, and pull the other end.

Machine basting is faster than hand basting, and is used to hold a seam or several layers of fabric together temporarily. However, it is not as useful for intricate work as hand basting.

stitching seams

Here is how to stitch the plain seams used in this book.

1 Place two pieces of fabric right sides together, aligning the raw edges. Pin the seam, placing the pins either at right angles to the seamline or along the seamline.

2 If necessary, baste (tack) the seam close to the seamline, just within the seam allowance. With the raw edges on the right, machine stitch a seam of the correct width. To keep the stitching straight, use the stitching guide or a piece of tape the correct distance from the needle.

3 At the beginning and end of each seam, do a few stitches in reverse to secure the thread. When stitching around curves, work slowly so that the curve will be continuous and gradual, and you won't stray off the seamline. It helps to use a slightly shorter stitch length here.

4 When you come to a corner, stop ⅝ in. (1.5 cm) from the edge, or whatever the width of the seam is. With the needle at its lowest point, raise the presser foot and pivot the fabric around until the new seamline is in line with the presser foot. Lower the presser foot and continue stitching along the new seamline.

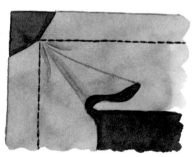

trimming and pressing seams

Seams need to be trimmed and pressed to make them lie flat.

1 On curved seams, clip into the seam allowance after stitching. For inward curves, the clips should be wedge-shaped notches. For outward curves, they just need to be slits.

2 On a point, trim away the seam allowances around the point. On square corners, snip off the corners of the seam allowances.

3 When a straight piece of fabric is stitched to a corner of another piece, clip into the seam allowance of the straight piece at the corner. This clip will open up and allow the edges to align with the edges either side of the corner on the other piece. Be careful not to snip beyond the seamline.

4 Press seams open from the wrong side, unless instructed otherwise. Do not press seams from the right side, as you may mark the fabric. If stitching together two pieces that already have seams, press open the first seams, snip off the corners of the seam allowances, and align the seams exactly (if appropriate) when pinning the fabric pieces together. While stitching the new seam, keep the seam allowances of the old seams flat.

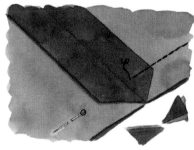

mitering corners

Mitered corners on a border create a neat, professional-looking finish.

1 Cut each border strip to the desired depth plus the seam allowance; lengthwise, each strip should be the length of the border plus twice the depth of the finished border. Press each border strip in half widthwise, then press the seam allowance along each long raw edge to the wrong side. Open out the strips. With right sides together, aligning the raw edges, pin and baste (tack) the first strip along one edge, leaving the same amount overhanging at each end. Machine stitch along the first crease, leaving the overlap and ½ in. (1 cm) at each end unstitched. Fold back the border strip to the right side, and press.

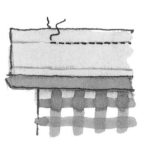

2 Attach the remaining border strips in the same way, taking care not to stitch into the adjoining border strips.

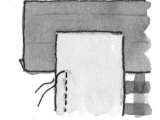

3 Fold each overlapping end of each strip to the wrong side, at a 45° angle. Pin the folds in place from the right side, and slipstitch together, making sure the miters match exactly. Then remove the pins and press the folds.

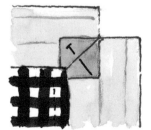

4 Fold in the remaining corners, as shown.

5 Slipstitch along the miter to complete.

hand stitches

There are many embroidery stitches; this section shows the ones I used in the projects, but you can, of course, substitute stitches of your own choice.

Slipstitch

Slipstitch is used to close openings—for example, when you've left a gap in a seam in order to turn a piece right side out—and to appliqué one piece of fabric to another. Work from right to left. Slide the needle between the two pieces of fabric, bringing it out on the edge of the top fabric so that the knot in the thread is hidden between the two layers. Pick up one or two threads from the base fabric, then bring the needle up a short distance along, on the edge of the top fabric, and pull through. Repeat to the end.

Running stitch

Work from right to left. Secure the thread with a couple of small stitches, and then make several small stitches by bringing the needle up and back down through the fabric several times along the stitching line. Pull the needle through and repeat. Try to keep the stitches and the spaces between them the same size.

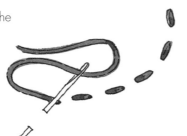

Whipped backstitch

Work a line of backstitches (see above). Using a blunt needle, slide the needle under the thread of the first backstitch from top to bottom and pull the thread through. Repeat in each stitch in the row.

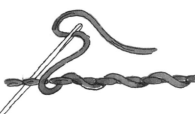

Whipped running stitch

Work a line of running stitches (see above). Using a blunt needle, slide the needle under the thread of the first running stitch from top to bottom and pull the thread through. Repeat in each stitch in the row.

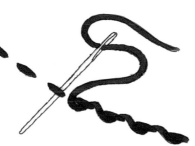

Couching

Lay a thread along the line to be embroidered. Bring another needle up just below the laid thread, take it across, and reinsert it just above the laid thread to form a small "tying" stitch. Repeat at regular intervals. The tying stitches can be in a different color to the base thread if desired.

Backstitch

Work from right to left. Bring the needle up from the back of the fabric, one stitch length to the left of the end of the stitching line. Insert it one stitch length to the right, at the very end of the stitching line, and bring it up again one stitch length in front of the point from which it first emerged. Pull the thread through. To begin the next stitch, insert the needle at the left-hand end of the previous stitch. Continue to the end.

Straight stitch

Straight stitches can be arranged to form other embroidery stitches, such as seed stitch, star stitch, and zigzag stitch (see below).

Seed stitch

Work pairs of very short straight stitches, positioning them randomly to fill an area.

Star stitch

Work a series of straight stitches from the outside of a circle to the center point to create a star shape. If you wish, you can further embellish this stitch by working a French knot at each point of the "star."

Zigzag stitch

Work a series of straight stitches in a zigzag formation. This is a useful stitch for decorative borders.

Cross stitch

To work a single cross stitch, bring the needle up at A and down at B, then up at C and down at D.
To work a row of cross stitches, work the diagonal stitches in one direction only, from right to left, then reverse the direction and work the second half of the stitch across each stitch made on the first journey.

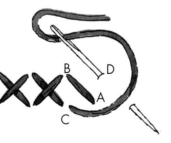

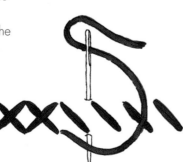

Herringbone stitch

Bring the needle up at A and down at B to form a diagonal stitch, them come up at C. Go down at D and up at E, ready to start the next stitch.

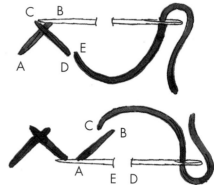

Chain stitch

Bring the needle out at the end of the stitching line. Re-insert it at the same point and bring it out a short distance away, looping the thread around the needle tip. Pull the thread through. To begin the next stitch, insert the needle at the point at which it last emerged, just inside the loop of the previous chain, and bring it out a short distance away, again looping the thread around the needle tip. Repeat to continue.

Detached chain stitch

Work a single chain, as above, but fasten it by taking a small vertical stitch across the bottom of the loop.

Daisy stitch

Work a group of six to eight detached chain stitches in a circle to form a flower shape.

Fly stitch

Bring the needle up at A and insert it at B, a short distance to the right, leaving a loose loop of thread. Bring the needle up at C, inside the loop, and insert it at D, outside the loop, to "tie" the loop in place. You can work this stitch singly or in rows.

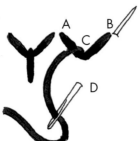

French knot

Bring the needle up from the back of the fabric to the front. Wrap the thread two or three times around the tip of the needle, then reinsert the needle at the point where it first emerged, holding the wrapped threads with the thumbnail of your non-stitching hand, and pull the needle all the way through. The wraps will form a knot on the surface of the fabric.

Chain and fly stitch

Work a chain stitch, followed by a fly stitch that forms a v-shape at the base of the chain loop. Tie the stitch down by working a small vertical stitch across the base of the v-shape. This stitch can be worked singly or in rows.

Coral stitch

Bring the thread out at the right end of the line to be embroidered, lay the thread along the line of the design, and hold it down with your left thumb. Take a small vertical stitch across the line, looping the thread under the tip of the needle. Pull through to form a small knot.

Bullion knot

This is similar to a French knot, but creates a longer coil of thread rather than a single knot. Bring the needle up at A and take it down at B, leaving a loose loop of thread—the distance from A to B being the length of knot that you require. Bring the needle back up at A and wrap the thread around the needle five to eight times, depending on how long you want the knot to be. Hold the wrapped thread in place with your left hand and pull the needle all the way through. Insert the needle at B and pull through, easing the coiled stitches neatly into position.

Satin stitch

This is a "filling" stitch that is useful for motifs such as flower petals and leaves. Work from left to right. Draw the shape on the fabric, then work straight stitches across it, coming up at A and down at B, then up at C and down at D, and so on. Place the stitches next to each other, so that no fabric can be seen between them. You can also work a row of backstitch around the edge to define the outline more clearly.

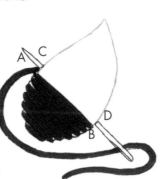

Buttonhole stitch for cutouts and eyelets

Draw two circles inside each other to the size required. Insert the needle on the inner line and bring it out on the outer line, taking a downward stitch with the thread under the needlepoint. Pull through to form a loop. Repeat around the circle, making sure that the stitches are formed close together.

N.B Blanket stitches are worked in the same way, but space is left between the stitches.

embellishments

Twisted cord

You'll need to either ask a friend to lend a hand (literally) or use your teeth! Cut a length of embroidery floss or yarn four times the length you want the finished cord to be. Fold it in half and hold the two ends in your left hand. Insert the index finger of your right hand in the loop at the other end and circle your hand around and around until the floss or yarn has twisted tightly against your finger. Ask your

friend to hold the middle (or grab it with your teeth), and bring your hands still holding the ends together. Let go of the middle and allow the two halves of the cord to twist around and around each other. Knot the ends or secure them by stitching into a seam, as in the curtain tieback on page 80.

Pompoms

Pompoms make an attractive finishing touch and add both texture and color to a project.

1 Take a ball of yarn and wrap it 25–30 times around your fingers.

2 Slip the wool from your fingers, tie a piece of longer yarn around the middle of the wound yarn and secure with a tight knot. Snip down the lengths of yarn on both sides so that the pompom will now measure about 1½ in. (3–4 cm) across. Fluff up the fibers and keep snipping to form a nice neat ball.

suppliers

index

Note: **Bold** page numbers refer to the Templates

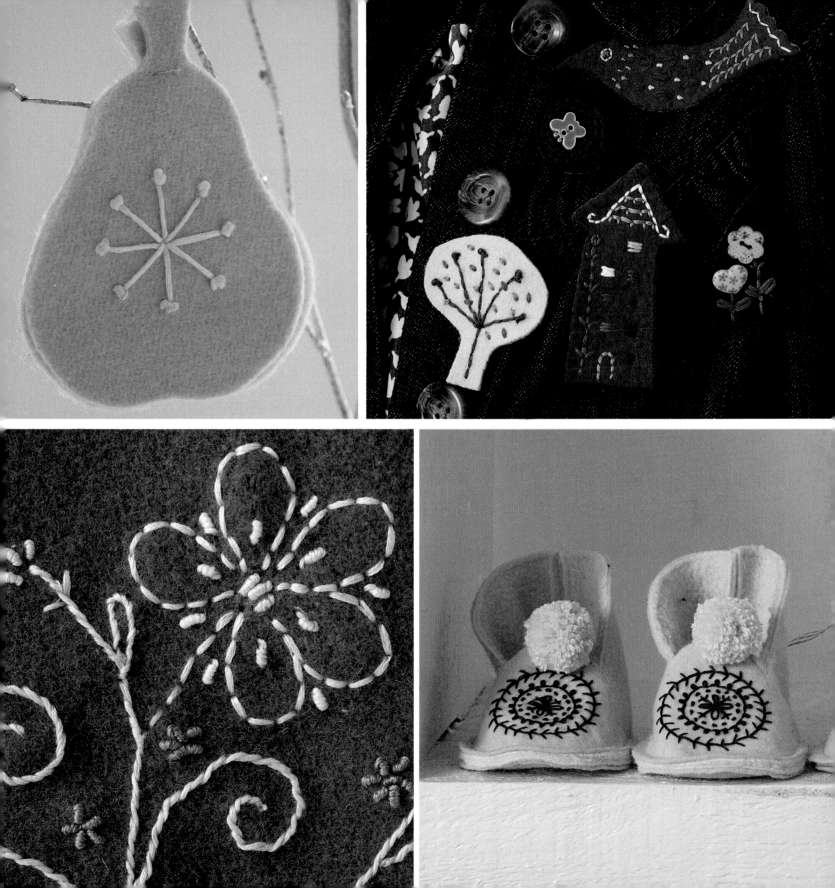

acknowledgments

I would like to thank all at Cico who helped put this book together, especially Cindy, Pete, Sally, and Sarah. To Kate for her charming illustrations, Chris for her lovely design, and to Claire Richardson and Carolyn Barber for their inspiring photography, with a special thanks to Claire and Ellie for making the shoots such enjoyable days. Thanks to Orla and Freya, the two gorgeous models, and to Gerry for having just the right props. Thanks to Virginia at roddyandginger.co.uk for the lovely bird print and Scandinavian ceramics, and to Lisa for letting me paint one of her chairs.

To Pip and Judith, my Stockholm Buddies, who bailed me out when I overdid the shopping on a trip to Scandinavia and went over my baggage limit and, of course, for all their support and encouragement, huge thanks to Ian, Milly, Florence, Henrietta, Harvey, and Rose.

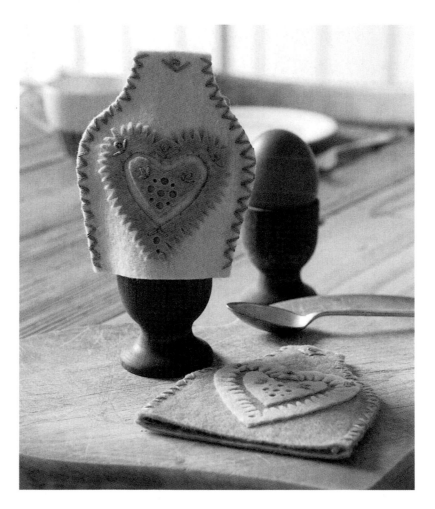